IMAGES
of America

WASHINGTON
COUNTY

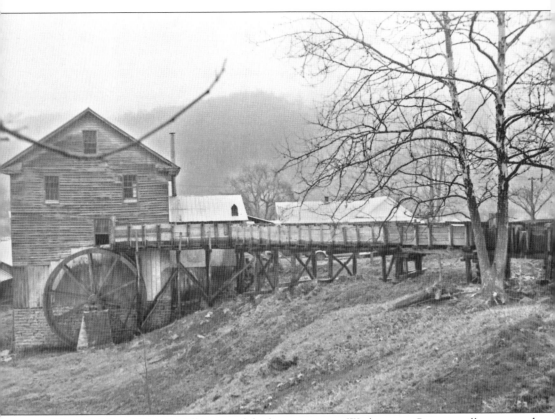

WHITE'S MILL. White's Mill is one of the last remaining Washington County mills open to the public. It is listed on the National Register of Historic Places. The raceway has been removed, and a nonprofit organization is working to stabilize the building and develop it as a historic center. (Courtesy Lowry Bowman.)

ON THE COVER: The River Bridge over the North Fork of the Holston was long a landmark for the Hayter's Gap community. This early-1900s photograph pictures George Johnson (left) and William Hockett (right) on the right end of the bridge. Irvin Johnson (left) and Lester Johnson (right) are astride the horses. The other folks are unidentified. The Johnson Store is the building just to the right of the bridge. (Courtesy Irene Johnson Meade.)

IMAGES
of America

WASHINGTON
COUNTY

Donna Akers Warmuth

ARCADIA
PUBLISHING

Published by Arcadia Publishing
Charleston SC, Chicago IL, Portsmouth NH, San Francisco CA

Printed in the United States of America

Library of Congress Catalog Card Number: 2006931972

For all general information contact Arcadia Publishing at:
Telephone 843-853-2070
Fax 843-853-0044
E-mail sales@arcadiapublishing.com
For customer service and orders:
Toll-Free 1-888-313-2665

Visit us on the Internet at www.arcadiapublishing.com

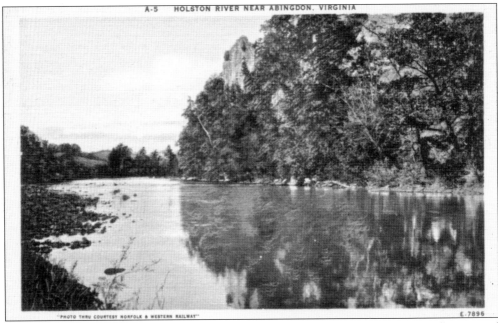

HOLSTON RIVER SCENE. This lovely view was produced as a postcard by the Asheville Postcard Company. The Holston River threads through the valley of southwestern Virginia, providing recreational opportunities and scenic beauty. The rocky cliffs along the edge of the Holston River are dramatic and now can be seen by pedestrians and bicyclists on the Virginia Creeper Trail, which was developed along the former Norfolk and Western Railway. (Courtesy Donna Akers Warmuth.)

CONTENTS

ACKNOWLEDGMENTS

This book is an informal collection of images that tells the stories of the people and the communities of Washington County, Virginia. It is not intended to be a formal history of the area but rather a walk through the past. Many of the facts and dates in this book are based on verbal information from image contributors, so minor discrepancies may exist. Efforts were made to verify dates and facts, but contradictory information was often found.

I would like to thank the numerous residents of Washington County for helping to preserve the built environment and photographic history of this unique area. I would like to specifically thank Harry Haynes with the Museum of the Middle Appalachians (MOMA) in Saltville for allowing me to use numerous images from their extensive collection and for assisting me with this research. Doug Patterson, a former local photographer, also generously allowed me to use images from his vast collection of photographs and assisted me with access to Lowry Bowman's collection. Louise Fortune Hall, the local historian of Damascus, was kind enough to let me search through her collection of Damascus photographs and use many of those images. Jeff Weaver, regional historian and author, also allowed me access to his large collection of photographs of the area. Thanks to the Historical Society of Washington County, Virginia, for compiling an enormous amount of historical data and allowing access to the public. The historical information in Nanci King's *Places In Time* series has been extremely helpful, and I would encourage those wanting to learn more about our area to consult these books. Thank you to the following individuals and groups who provided either images or historic information for this book: Lowry Bowman, Dr. Paul Brown, Kimberly Byrd, Mary Love Johnson Caudill, Howard Davis, Lewis Berry Garrett, Edith Stevens Godbey, Harry Haynes with MOMA, Louise Fortune Hall, the Hayter's Gap branch of the Washington County Public Library, Gerald C. and Kitty Henninger, Helen Hill, Mike Hoback, Garrett Jackson, the Jack Kestner family, Susie Copenhaver Lang, Nancy Gray Lowry, Tom McConnell, Ida Mae McVey, Irene Johnson Meade, James Miller, Harry Minnick, Sherrill Necessary, Juanita Mock Neese, Doris O'Quinn, Doug Patterson, Marilou Hall Preston, Phyllis Price, Jerry Ratcliff, Dorothy Ray, Southwest Virginia 4-H Center, Joe Smith, Colleen Davenport Taylor, Jack Taylor, Debbie Wilkinson Tuell, Jeff Weaver, William and Betty Webster, and Larry Webster.

Finally, thanks for the encouragement to continue on with this project from fellow Arcadia authors Kimberly Byrd and Sonya Haskins. The assistance and advice of Kathryn Korfonta and Courtney Hutton with Arcadia Publishing have been very helpful in completing this book. Thanks to my husband, Greg, and our two sons, Owen and Riley, for understanding the time commitment that putting this book together required. Thanks as always to my mother, Nellie Akers, and sister, Deanna Akers Greene, for encouraging me and providing shoulders to lean on.

INTRODUCTION

Native Americans once occupied this fertile river valley, but only scattered archeological sites from their occupation remain. At the time of European exploration, these lands were merely hunting grounds for the Cherokee, Shawnee, and Six Nations Tribes. In 1746, Thomas Walker and surveyors from the Loyal Land Company were the first to survey land here. Soon afterward, these fertile lands attracted settlers from the more populated regions of Pennsylvania, Maryland, and the Valley of Virginia who were interested in land, game, wealth, and personal freedom.

However, conflicts with Native Americans soon developed over the land, and forts were built along the rivers for protection. Black's Fort was built by Joseph Black in 1774 near today's Abingdon. Conflicts with Native Americans were common, and settlers fled back up the Valley Road leaving the area. Not until after the Revolutionary War did residents return in numbers to this new territory.

Washington County was established from Fincastle County in 1776 and was the first locale to be named for George Washington. The counties of Buchanan, Dickenson, Wise, Russell, Scott, Smyth, Lee, and Tazewell were divided from the larger Washington County. The first court for Washington County took place at Black's Fort in January 1777.

The Great Valley Road became the main road to the western territory. Historians estimate that over 100,000 settlers traveled through Abingdon and onto the Wilderness Trail to Kentucky during the period from 1780 until 1790. Abingdon was the final town in which to obtain money and gather supplies for the long journey. In 1780, some 400 men in a volunteer militia from Washington County under Gen. William Campbell marched over the mountains to King's Mountain, South Carolina, where they defeated the British. The Battle of King's Mountain was one of the turning points in the Revolutionary War. The county supplied brave volunteer soldiers to the War of 1812 and the war with Mexico in 1846. Many area soldiers joined the Southern cause during the Civil War, and two Union raids occurred in Washington County to capture the salt mines of Saltville and to cut off the railroad.

Many communities grew up around water resources, fertile land, gristmills, or later on railroads and locations of natural resources. Market and governmental towns developed, such as Bristol and Abingdon. Other smaller communities, such as Glade Spring and Meadowview, grew as shipping locations for goods, produce, and livestock on the railroads in the 1850s through the mid-1900s. When the trains left, commercial growth in these villages fell off sharply, and today these are mainly residential communities with some local services. The timber boom created jobs and growth in towns like Damascus and Konnarock, and when the forest resources were depleted, the towns seemed to go back to sleep. Damascus is an exception, as it reinvented itself as a trailhead for the Virginia Creeper Trail, a popular pedestrian and bike trail along the former Norfolk and Western Railway. Early industries attracted to the mineral resources created growth in the towns of Saltville and Plasterco, but none are still operating there today. Even though the economies of the communities have changed drastically, most residents have remained in the area and work in the service economy. The region, with its rolling hills and meandering streams, has created a people who love the land, the mountains, and family. A sense of individualism and pride in the residents have created a vibrant, Appalachian community that is trying to find a new direction to keep the younger generations from leaving for jobs in urban areas. The region has had some success with attracting high technology industries, and tourism is a growing sector for the entire county.

In 2000, the population of Washington County was 51,103, while Abingdon had 7,780 residents, Glade Spring had 1,374 residents, and Damascus had 981 residents (2000 Census).

BIBLIOGRAPHY

Hall, Louise Fortune. *A History of Damascus 1793–1950*. Abingdon, VA: John Anderson Press, 1950.

The Historical Society of Washington County, Virginia. "Washington County Grist Mills," *The Historical Society of Washington County, Virginia Publication* Series II, No. 12, 1974–1975.

The Historical Society of Washington County, Virginia. Miscellaneous files.

Kearfott, Clarence Baker. *Highland Mills*. Bluff City, TN: B&I Printing, 1970.

King, Nanci C. *Places in Time: Volume I Abingdon, Virginia 1778–1880*. Abingdon, VA: Nanci C. King, 1989.

———. *Places in Time: Volume II Abingdon, Meadowview, and Glade Spring, Virginia*. Abingdon, VA: Nanci C. King, 1994.

———. *Places in Time: Volume III South from Abingdon to the Holston*. Abingdon, VA: Nanci C. King, 1997.

McGuinn, Doug. *The Virginia Creeper*. Boone, NC: Bamboo Books, 1998.

Neal, J. Allen. *Bicentennial History of Washington County, Virginia*. Dallas, TX: Taylor Publishing, 1977.

Summers, Lewis Preston. *History of Southwest Virginia 1746–1786, Washington County, 1777–1870*. Reprinted. Johnson City, TN: The Overmountain Press, 1989.

Tennis, Joe. *Southwest Virginia Crossroads*. Johnson City, TN: The Overmountain Press, 2004.

Warmuth, Donna Akers. *Abingdon, Virginia*. Charleston, SC: Arcadia Publishing, 2002.

One

FRIENDS AND FAMILIES

Many of today's residents of Washington County are descended from the early settlers who braved Native American conflict and the wild frontier to settle this fertile river valley. These settlers mainly came into the region through the Great Wagon Road or the Valley Road, which leads south from Pennsylvania to Tennessee. Others crossed over the mountains from North Carolina. Settlement initially began in Smyth County and then spread southward. Rural settlements grew up quickly, as evidenced by the following list of unincorporated villages that had post offices in the 1930s: Meadowview, Wallace, Benhams, Lodi, Alum Wells, Alvarado, Wyndale, Plasterco, Robuck, Glenford, Emory, Konnarock, Greendale, Wolfrun, Green Cove, Clinchburg, Taylor's Valley, Holston, Cole, and Zenobia. Smaller communities were often the site of a crossroads, resort, or railroad siding and included Phillip, Hayter, Creek Junction, Litz, McConnell, Mountain, Watauga, Drowning Ford, Fleet, Brumley Gap, Vail's Mill, Washington Springs, Friendship, Ora, Laureldale, Grassy Ridge, and Lindell. Many of these communities have been forgotten today.

Many of the early settlers were Ulster-Irish, German, English, Welsh, and Swiss and were second or later generations from mainly Pennsylvania, Maryland, and eastern Virginia. These hardy people quickly adapted to the new American worldview and became part of Appalachia. The lingering contributions of these European cultures can be found today in the area's bluegrass music and ballads, folk tales, speech patterns, and superstitions.

Farming was a necessity of life for most folks, but others engaged in business, logging, railroad work, trades, and industry. Today farmers are a disappearing segment of the population, although several Washington County farms have been in the same families for 100 or even 200 years. Although three Virginia governors came from Washington County—John B. Floyd, Wyndham Robertson, and David Campbell—it is the ordinary people who made the greatest contribution. These names of ordinary folk have been forgotten, although it was upon their backs that this region was built.

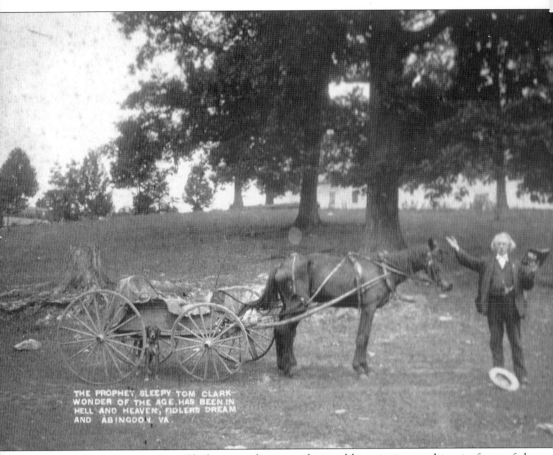

THE PROPHET SLEEPY TOM CLARK-
WONDER OF THE AGE, HAS BEEN IN
HELL AND HEAVEN, FIDLERS DREAM
AND ABINGDON, VA.

SLEEPY TOM CLARK. Tom Clark, a traveling preacher and hermit, is preaching in front of the Washington Chapel on Walden Road. A unique character, "Sleepy Tom" traveled throughout the area in an old wagon and practiced a brisk trade of horse and dog trading. His name came from his ability to lie down and sleep anywhere and anytime. He had cards printed that claimed he had been "to Heaven and Hell and Abingdon, Virginia." Clark insisted that he had once died and visited both the upper and lower destinations and decided to return to the land of the living. When he became sick and was in the hospital, the staff was amazed to peel off his multiple layers of clothing, which weighed about 43 pounds. He is buried in the Keller cemetery off Cleveland Road. (Courtesy Harry Minnick.)

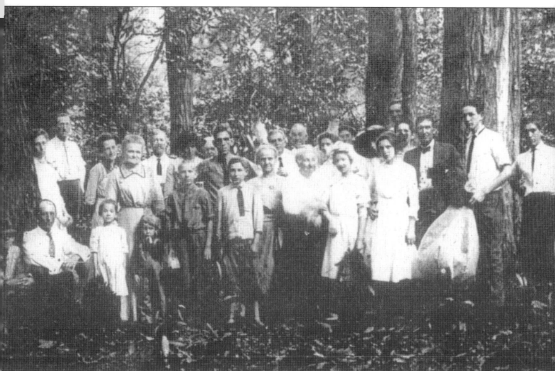

PICNIC IN DAMASCUS. This 1912 photograph shows the owners and managers with families of the Thayer Company, Smethport Extract Company, and the Damascus Lumber Company on a picnic "up the Laurel" outside Damascus. The families took the narrow-gauge train to arrive at the location. The Thayer Company Dimension Plant was established in 1902 and manufactured window sashes, doors, and tabletops. The Smethport Extract Company was begun in 1905 and sold bark extracts. Begun in 1906, the Damascus Lumber Company cut lumber in the area until the plant was destroyed by fire in 1921. This company built a railroad line into Ashe County, North Carolina, which was the first rail in that county. Pictured from left to right are (first row) Donald Baker, Frank Thurston, Jeanette Baker, Alden Baker, Harold Baker, Wilton Mock, Mrs. Joe King, Mrs. Cox, Ellen Mock, Effie Rhea, J. F. Rhea, Karl Mock, and Harry King; (second row) Alice Burr, A. A. Mock, Mrs. Charles Baker, Mrs. Frank Thurston, Joe King, Mrs. J. F. Rhea, Charles Baker, George Clements, John Rooney, Mrs. B. W. Mock, Mrs. A. A. Mock, and B. W. Mock. (Courtesy Louise Fortune Hall.)

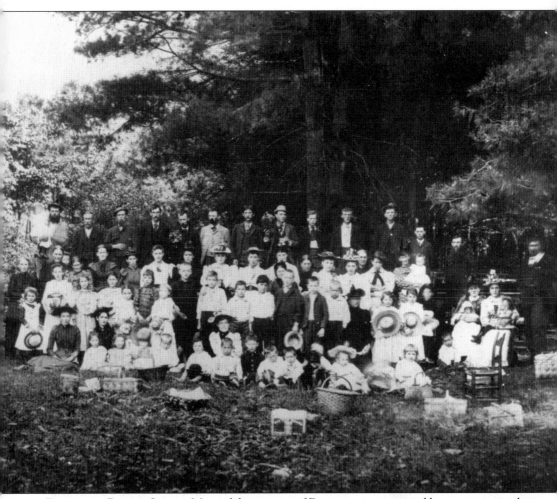

DAMASCUS PICNIC GROUP. Most of the citizens of Damascus are pictured here at a picnic along Beaver Creek in 1893. Pictured from left to right are (first row) Docia Waugh; Mrs. A. A. Mock and children; Mrs. J. D. Imboden with Frank Widener; ? Donnelly; other unidentified children; and Jamie Mock; (second row) Polly Wright Mock; girls including Mary Keys, Bertha Keys, and Lucy Widener; boys including Hugh Keys (in dark suit), ? Donnelly, and John Thomas; (seated) Mrs. Snodgrass, Mrs. Lafayette Ramsey, and Mrs. Ritchie and infant; (third row) Mrs. W. D. Rambo; Becky Wilson; Mrs. John Mock; Mrs. Morrison; Jane Hand; Mrs. Trout; Lillie Sheets; Jennie Hand; Birdie Rambo; Mrs. John Ramsey; Lillie Rambo Scott; Callie Ramsey; Linda Wilson; Ellen Neeley; and Mrs. James D. Keys; (fourth row) P. W. Wright; George Lipps; James D. Keys; Dave Mock; George Suit; Lafayette Ramsey; William Johnson; R. E. Fortune; James Ramsey; Joe Neal; W. A. Wilson; Walter Ramsey; and A. A. Mock. (Courtesy Louise Fortune Hall.)

FIRST MAYOR OF DAMASCUS. Walter Harland Fortune was the first mayor of Damascus and a descendant of the Fortune family who moved to Damascus to oversee construction of the railroad. He was the father of Louise Fortune Hall, today's knowledgeable town historian. (Courtesy Louise Fortune Hall.)

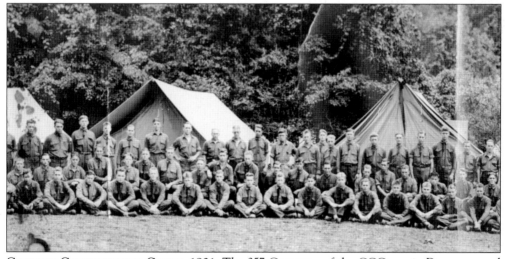

CIVILIAN CONSERVATION CORPS, 1931. The 357 Company of the CCC was in Damascus and built a telephone line from Damascus to Konnarock and to Carroll County. The men, who were from all over the region and as far away as New York, lived in tents until barracks were constructed. Several local men in this company were Kelsey Brown of Damascus, Cicero Fletcher, Parker Fritz, McKinley Low, Robert Ward, and Maj. Harry Tomlinson. (Courtesy Louise Fortune Hall.)

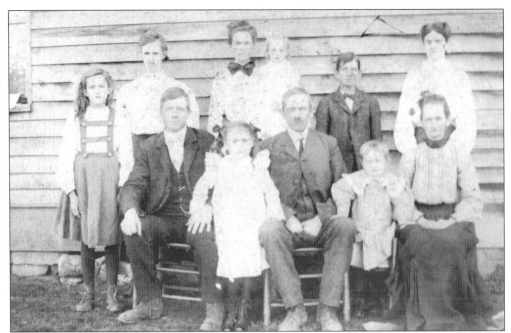

RAINES FAMILY. The Raines family were early settlers in the Old Saltworks community. Pictured from left to right are (first row) Walter Yeatts, Ethel Raines, James P. Raines, Robert H. Raines, and Nannie Yokum Raines; (second row) Elizabeth Raines, Arlena Raines, Hattie Raines Yeatts, Kate Yeatts, Albert Raines, and Margaret Raines. (Courtesy Harry Minnick.)

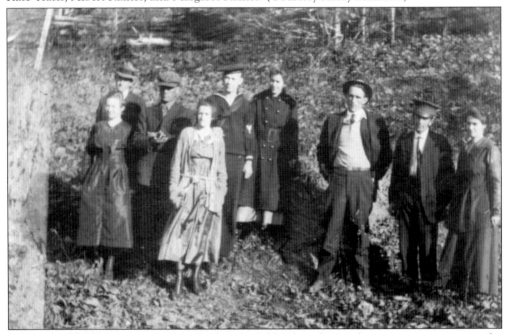

OUTING C. 1915. This group of locals from the Old Saltworks Road area is on an outing in the woods. Pictured from left to right are Lucy Kate Preston, Albert Raines, David Colley, Elizabeth Raines, Edward Woodson, Garnet Neal, Will Colley, Ewell Minnick, and Maggie Raines. (Courtesy Harry Minnick.)

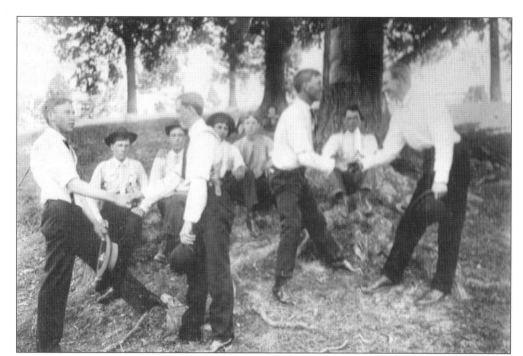

WASHINGTON CHAPEL PICNIC. Leave it to the boys to cut up, even at a church picnic. Pictured from left to right are (standing) Ernest Hawthorne, ? Garrett, and two unidentified boys; (seated) two unidentified boys, Ewell Minnick, unidentified, and Frank Colley. (Courtesy Harry Minnick.)

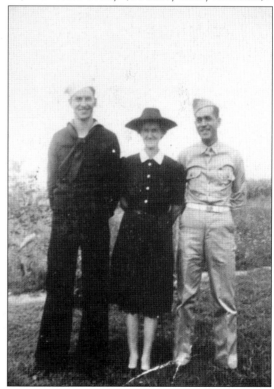

MINNICK FAMILY. Pictured from left to right are James P. Minnick (1920–1985), Margaret Raines Minnick (1888–1964), and Harry Hunter Minnick (1919–). Jay served with the medical personnel in the U.S. Navy attached to the 4th Marine Division in the Pacific. Harry served as a staff sergeant in the army from 1941 to 1945 in the European theater. Later Harry became a mainstay of the Kroger produce department, where he worked for many years. (Courtesy Harry Minnick.)

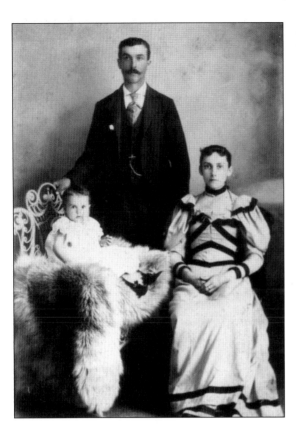

GARRETT FAMILY C. 1900. This Cleveland community family included Lee Francis Garrett, his wife, Callie Anne Combs Garrett, and their child, Blanche Edith Garrett. (Courtesy Lewis Berry Garrett.)

BERRY TEACHERS. The Berry family has been in the Cleveland community for many years. Pictured from left to right are (first row) Margaret Berry Garrett (teacher at Cleveland School) and Ruth Berry Stiles (teacher at Abingdon Elementary); (second row) Virginia Berry Gray (teacher in Bristol schools) and their mother, Susan McConnell Berry. (Courtesy Lewis Berry Garrett.)

16

CLEVELAND SWEETHEARTS. Stanley Lee Garrett and Margaret Elizabeth Berry are pictured here while courting. Garrett was a farmer, and Margaret attended Stonewall Jackson Institute. They were the parents of Lewis Berry Garrett of Cleveland. (Courtesy Lewis Berry Garrett.)

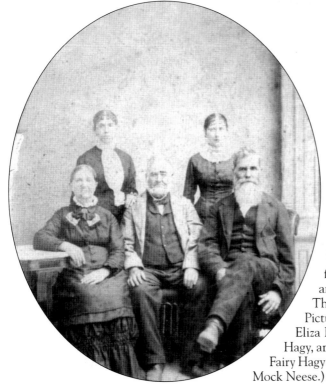

HAGY AND HORTENSTINE FAMILIES C. 1900. The Hagy family was an early landowner in the area and owned several businesses. These families lived near Meadowview. Pictured from left to right are (first row) Eliza Hortenstine Hagy, William Conn Hagy, and Jacob Hortenstine; (second row) Fairy Hagy and Jenny Hagy. (Courtesy Juanita Mock Neese.)

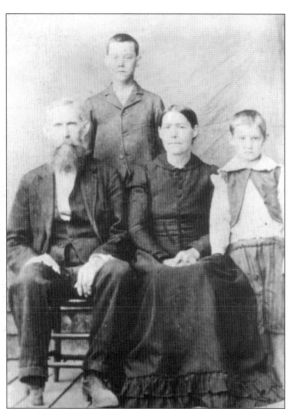

JAMES ANDREW MOCK FAMILY. This early photograph shows, from left to right, James Andrew Mock, Mack Mock, Jane Allen Mock, and Bert Mock of the Meadowview area. (Courtesy Juanita Mock Neese.)

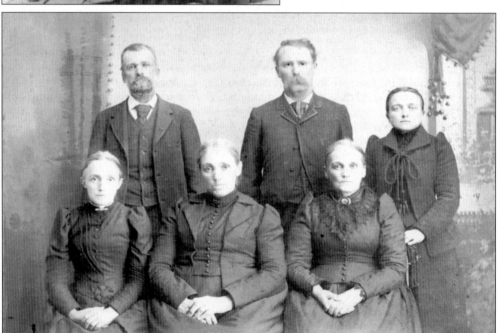

CLARK FAMILY C. 1900. The Clark family lived in the Meadowview area. Pictured from left to right are (first row), Nannie Hayter, Mary Clark, and Eps Clark McCampbell; (second row) Pleasant David Clark, John Clark, and Margaret Clark Ryan. (Courtesy Juanita Mock Neese.)

Dr. Samuel H. Yokeley. Pictured is Dr. Yokeley, who was Meadowview's doctor after World War I. Dr. Yokeley served in World War I and moved from Buena Vista, Virginia, to Meadowview. He practiced medicine for more than 30 years. His office was located on the second floor of the Maiden and Son Store and then later in a brick office built beside his home near downtown. He was one of the first people in town to own an automobile, but he often had to pay house calls on horseback because of the lack of good roads. Other early doctors in Meadowview included Dr. Joseph D. Alderson, Dr. W. L. Davenport, and Dr. E. E. Epperson. (Courtesy Edith Stevens Godbey.)

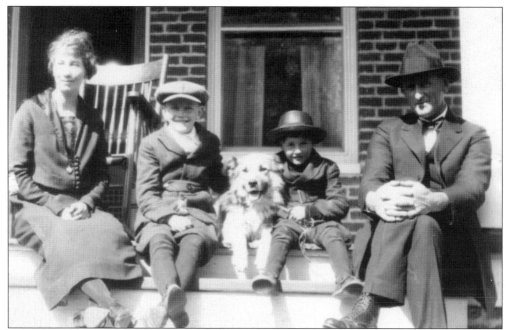

LOWRY FAMILY C. 1920. The Lowry family lived in the Green Spring community. Pictured from left to right are Bessie Ritchie Lowry, R. K. Lowry Jr., Charles J. Lowry, and R. K. Lowry Sr. Lowry Sr. established an early real estate company in the area, the Lowry Land Company, and both sons worked in real estate also. (Courtesy Nancy Gray Lowry.)

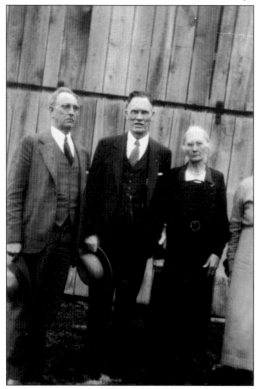

KINSOLVING FAMILY. The Kinsolving family lived in the Green Spring area. Pictured from left to right are Dr. Charlie Kinsolving, Dr. David Kinsolving, and Nannie Kinsolving White. Dr. David Kinsolving was the first doctor in the Green Spring area and practiced from the early 1900s until World War I, when he was a medical officer overseas. (Courtesy Nancy Gray Lowry.)

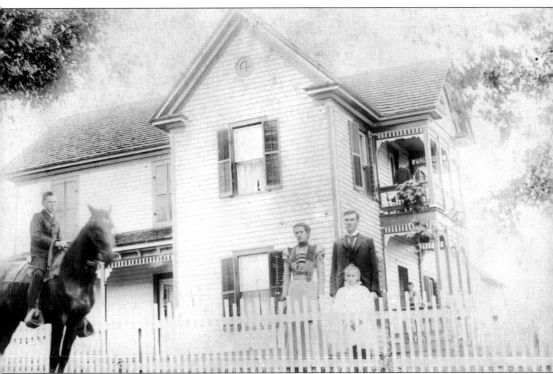

DR. AND MRS. KINSOLVING. Lula Denton Kinsolving and Dr. David L. Kinsolving are standing in front of their house in the Green Spring community. They had this two-story frame house built in 1897 on their property along Wolf Creek. A small separate building housed Dr. Kinsolving's medical office. The doctor was well respected in the community. After moving to Colorado for a time and serving as a medical officer overseas in World War I, Dr. Kinsolving returned to the area and moved to the town of Abingdon. This frame house was later torn down and replaced with a brick house. (Courtesy Nancy Gray Lowry.)

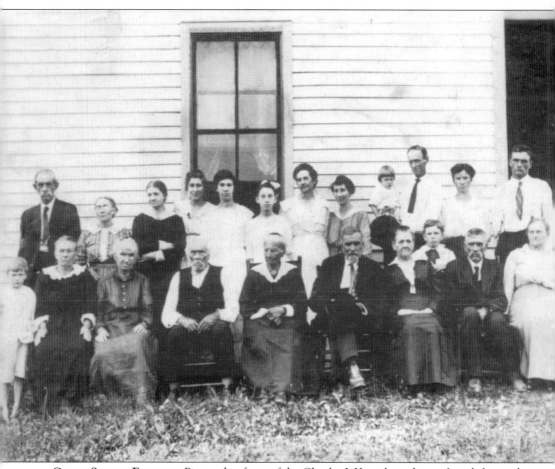

GREEN SPRING FAMILIES. Pictured in front of the Charles J. Kinsolving house from left to right are (first row) R. K. Lowry Jr., Hennie Sweet, Mattie Kinsolving, Charles J. Kinsolving, ? Kinsolving, John Phipps, Sally Phipps, Richard Harley, Bill Harley, and Ellen Harley; (second row) Frank White, Nannie White, two unidentified, Minnie White, Lula White, Lula Kinsolving, Bessie Ritchie Lowry, Charles Lowry (child), R. K. Lowry Sr., Mattie Rock, and Charles Harley. Living in close proximity, several of these families intermarried over the years. Behind them is the two-story Dr. Charles Kinsolving house, which was built in 1912. The house is still standing in the Green Spring community. (Courtesy Nancy Gray Lowry.)

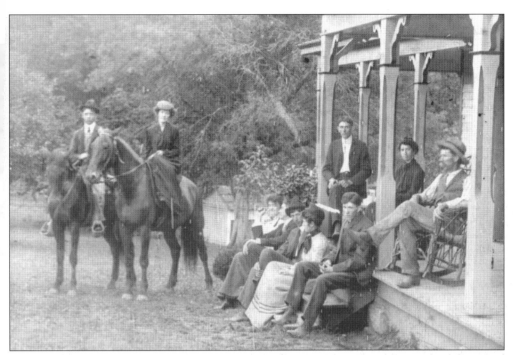

LOWRYS RELAXING. This group of Lowrys and friends were relaxing on the porch of the David P. Lowry house in Green Spring. Sitting on the end of the step is Gardner Lowry, and behind him on the porch is D. P. Lowry. (Courtesy Nancy Gray Lowry.)

WILLIAM THOMAS MCCONNELL. The McConnells are one of the older families of the Green Spring area. Pictured here is William Thomas McConnell (1856–1930), who was a farmer and owner of a grocery and general store in the Green Spring area. The post office was located in his store from 1889 until 1892, and he served as postmaster. (Courtesy Kitty Henninger.)

CATHERINE MCCONNELL. Catherine Sanders McConnell (1902–1985) was not only a lab technician for the State of Virginia, but she also devoted many hours of research to produce *High On a Windy Hill* (1968), a comprehensive survey of early cemeteries in the county. McConnell was an active member of the Historical Society of Washington County, Virginia. (Courtesy Kitty Henninger.)

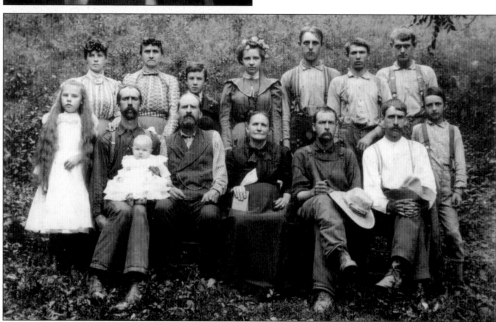

NECESSARY FAMILY OF MENDOTA C. 1900. The Necessary family descends from early settlers in the Mendota area. Most of these family members are unidentified. Pictured in the back row, second from the left, is Martha J. Moore Necessary; third from left is Archimedes Necessary; fourth from left is Mary Jane Necessary; and fifth from left is Robert (Mannie) Necessary. (Courtesy Sherrill Necessary.)

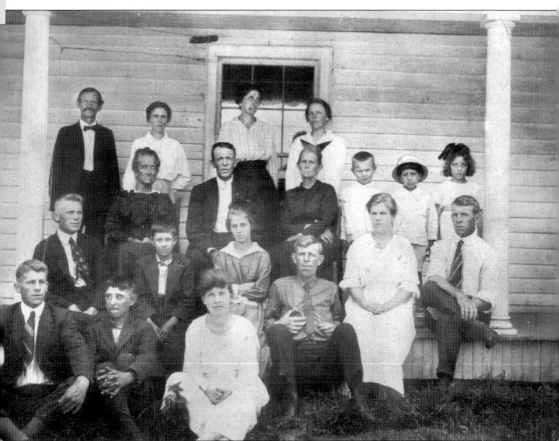

SMITH/FLEENOR FAMILIES. The Smith and Fleenor families who lived near Benhams were dressed for church in this early-1900s photograph. These folks are from some of the earliest families in the Benhams area. Pictured from left to right are (first row) John W. Smith III, Jess Fleenor, and Esther Smith; (second row) Walter Smith, Lawrence Fleenor, Tennie Smith, James Smith, Ethel Smith, and B. T. Smith; (third row) Lydia Shipley Cross, John W. Smith II, Margaret Sharrett Smith, Earl Smith, Bascom Fleenor, and Eunice Fleenor; (fourth row) ? Sharrett, ? Sharrett, Nellie Cross Fleenor, and Rachel Smith Leonard. (Courtesy Joe Smith.)

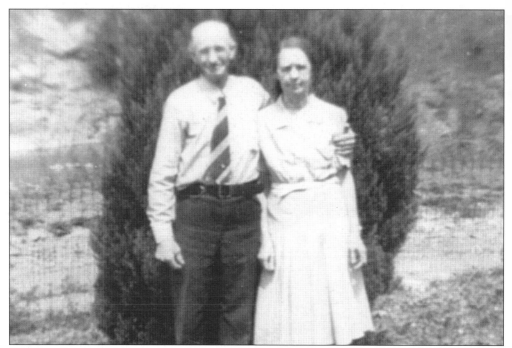

KESTNER FAMILY. Walter J. Kestner (1880–1963) married Lottie Annis Gilmer (1888–1946), and they raised five daughters in various locales in the county. Kestner was a miller by trade and was the miller at White's Mill and various mills in the county. As a miller, he had to move around to make his living. The Kestners originally settled in the Brumley Gap area of the county. (Courtesy Donna Akers Warmuth.)

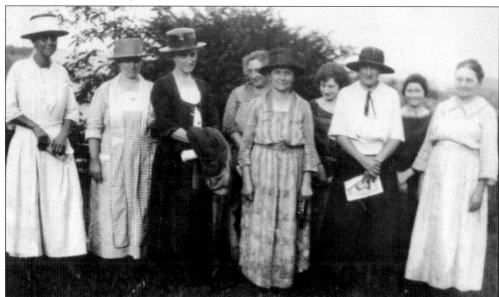

MISSIONARY LADIES C. 1920. These Baptist ladies attended the Greenfields Baptist Church on Cedar Creek Road and served their community. From left to right are Mattie Edmondson, Mrs. ? Bryan, Annie B. Edmondson, Aldonia Snodgrass Mast, Mrs. Dave Snodgrass, Pauline Littreal Horn, ? Spriggs, Margaret Littreal Ritchie, and Mrs. ? Littreal. (Courtesy Juanita Mock Neese.)

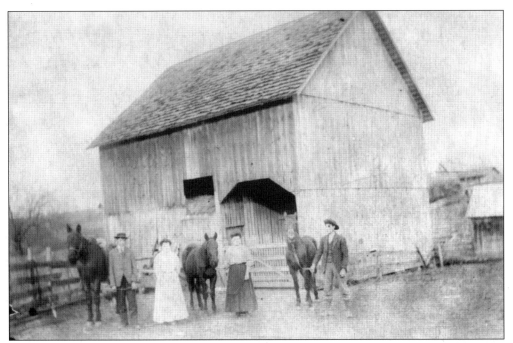

MOUNTAIN FAMILY. Members of the Mountain family stand holding horses on their farm in the Friendship community. From left to right are Lee Mountain, Lydia Mountain (Troxel), Lou Mountain (McKee), and Noah Mountain. (Courtesy Dorothy Ray.)

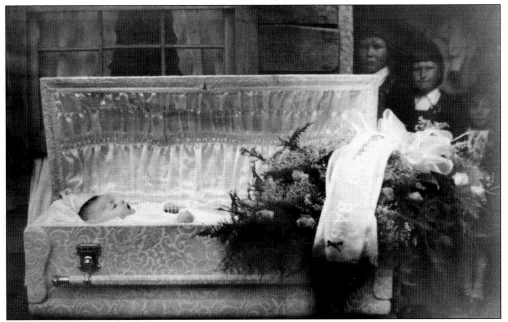

WAKE. Although sad, this funeral photograph for infant Nancy Pippin reflects the reality of childhood mortality rates in the early 1900s. It was the custom to lay out the deceased at home and have visitation there. The Pippin family lived in the Childers Hollow area. The fancy casket shows the care with which even a family of limited means would honor their loved ones. (Courtesy Garrett Jackson.)

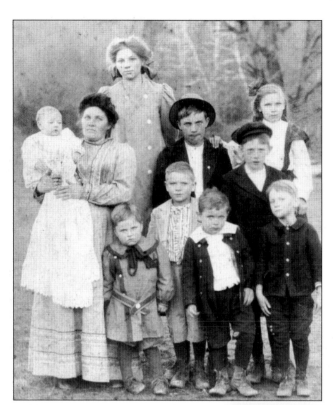

HEARL FAMILY. The Hearl family lived in the Greendale area. The only identified persons in the photograph are Barbara Hearl, the tallest girl in the back, and Lucy Hearl, the girl on the far right in back. (Courtesy Garrett Jackson.)

NEWTON KING PIPPIN. Newton Pippin was a descendant of William King, a prominent landowner and businessman in early Abingdon. He lived in Abingdon but owned a farm in Wyndale. The first Pippins were French Huguenots who left Blois, France, in the mid-1600s. His ancestor, Robert Pippin Sr., was a Revolutionary War soldier. (Courtesy Garrett Jackson.)

Taylors from Cedar Bluff. Rebuen Kilby Taylor and Mary Eliza Holden Taylor lived in the Cedar Bluff area. They owned most of the land from the school to the National Forest property. Rebuen Taylor served as the superintendent of Sunday school at the Cedar Bluff Methodist Church. (Courtesy Jack Taylor.)

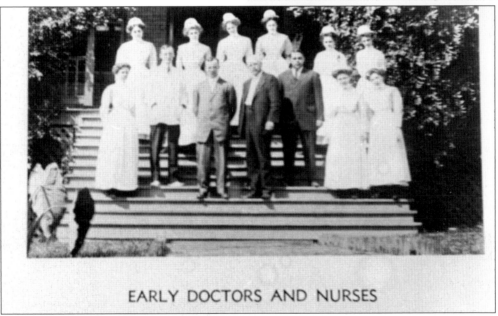

EARLY DOCTORS AND NURSES

Early Doctors and Nurses. This older photograph shows a group of Abingdon's hospital doctors and nurses. Pictured from left to right are (first row), Mamie Rice, Dr. Frank Smith, Dr. B. C. Willis, Dr. George Ben Johnston, Dr. Roy Cannaday, Margaret Palmer, and ? Owen; (second row) Werta Johnson, Irma Harris, Tizzie Bridges, Louise Allen ?, Louise Copeland, and Billy Wilson. (Courtesy Lowry Bowman.)

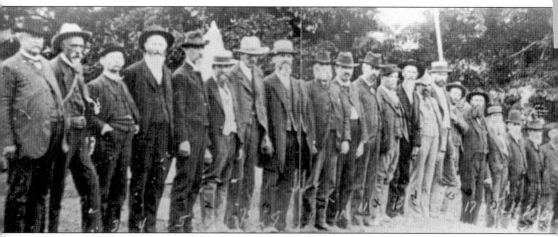

CIVIL WAR VETERANS. These Civil War veterans from part of the county gathered for a reunion. This corner of far southwestern Virginia suffered during the Civil War, with dwindling food supplies and marauding soldiers robbing food, money, and livestock. The Yankees came through Washington County two times on their way to Saltville to cut off a major salt supply of the Confederacy and to destroy the railroad. Most of the county residents enlisted in the Confederate troops, but a few men served with the Union army. By 1864, Washington County had supplied at least 2,000 soldiers to the Confederate army. The only identified person is the fifth person from the left, Dr. William Logan Dunn, who was assistant surgeon to Gen. John S. Mosby of the 43rd Virginia Calvary Infantry. Dunn was born near Glade Spring, attended Emory and Henry College, and conducted a medical practice in Glade Spring. He is buried in the old Glade Spring Presbyterian Church cemetery. (Courtesy MOMA.)

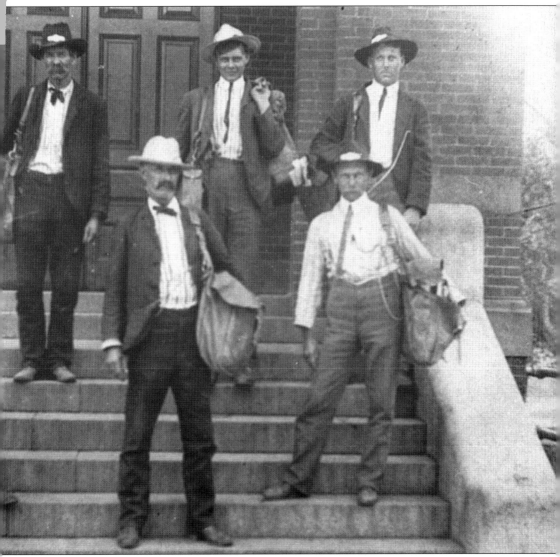

POSTAL CARRIERS. This pre-1917 photograph of the area's postal carriers shows large saddlebags of mail used for delivery in the early days. With the steep topography and rural landscape, mail was delivered on horseback longer here than in most areas. This job was not for either the faint of heart or body. They appear to be standing on the steps of the federal courthouse and post office, which was built in Abingdon in 1891. Pictured from left to right are (first row) Joe Estep and John Mahaffey Sr.; (second row) C. S. Doc ?, Clarence Rush, and J. A. Roberts. Mahaffey carried mail in the Alvarado region. Abingdon was the central postal delivery office for much of southwest Virginia, East Tennessee, and Kentucky in the early 1800s. (Courtesy Lowry Bowman.)

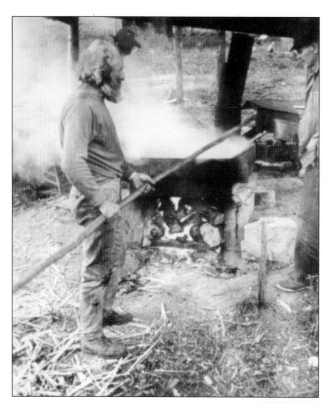

HOMER DAVENPORT. Homer Davenport, the well-known "Mountain Man," was a legend in the region and lived almost self-sufficiently on Clinch Mountain. He is shown here making molasses the old-timey way. (Courtesy Colleen Davenport Taylor and Hayter's Gap branch of the Washington County Public Library.)

ROBERT PORTERFIELD. This native son of southwest Virginia was the founder of the world-famous Barter Theatre, which is located in Abingdon. It was his idea to provide jobs for unemployed actors during the Depression and allow spectators to barter food and other items to see live theater. He lived for many years at Twin Oaks near Meadowview. (Courtesy Larry Webster.)

Two

EDUCATION
AND RELIGION

The first schools were held in log buildings and often church buildings as well. The typical 19th-century one- or two-room school was a white frame building with a rooftop bell and an outhouse. In 1860, Washington County had 48 public schools, 48 teachers, and 1,861 enrolled students. In 1860, the county had one college with 8 teachers and 200 students and one academy with 1 teacher and 15 students. By 1882, Washington County had 107 schoolhouses. In the late 1800s, the beginnings of a county school system were established with John Hogshead named as the first school superintendent. Following a national trend of consolidation and educational improvements, by 1936, there were 84 schools in the county, and the number decreased to 34 schools by 1958. Early books were the *Blue Back Speller*, *McGuffey's Reader*, and *Davies' Arithmetic*. Today several modern elementary schools, middle schools, and high schools serve the students of Washington County.

Most of the settlers of the county were Protestants, and their ancestors had come to this country for religious freedom. So it's not unexpected that so many different Protestant congregations split off in this region. The first settlers needed places to meet and worship and often met in members' houses. Circuit ministers were common in the early days. The Presbyterians were the earliest formally organized congregation with the Sinking Spring and Ebbing Spring churches. Several branches of Methodists and Baptists flourished, and Lutheran churches began later. Social life revolved around the churches in the early days, and many folks still participate in religious life today. The number of past and current churches in the county is numerous and would fill a book, so the author attempted to document only a few early churches to represent some communities.

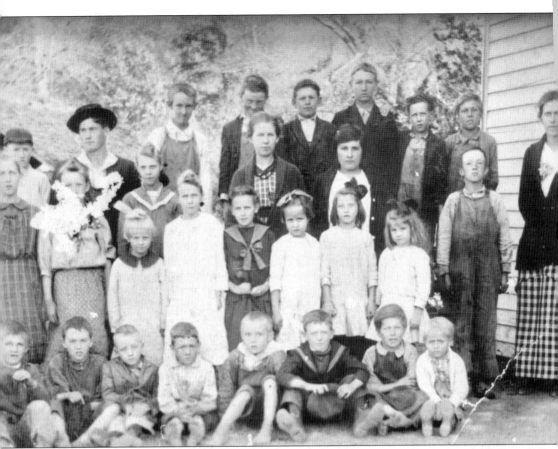

CEDAR BLUFF SCHOOL, 1918. These were students at Cedar Bluff School near Damascus in 1918 and are pictured in front of their school across from the Cedar Bluff United Methodist Church. Pictured from left to right are (first row) Leonard Vestal, Herbert Sweet, Robert Campbell, Howard Taylor, Earl Sweet, Paul Brown, George Vestal, and Henry Greer; (second row) Millie Watson, Monnie Sweet, Mary Anderson, Rhoda Anderson, Thula Anderson, Rosa Campbell, Lucy Cummings, Jennie Trent, Carrie Trent, Lowry Campbell, and Garnette Neal; (third row) Clinton Taylor, Preston Trent, Sam Sweet, Paul Anderson, Eva Watson, Charlie Brown, Ervin Taylor, Marie Camper, Charles Cummings, and Lee Vestal. (Courtesy Jack Taylor.)

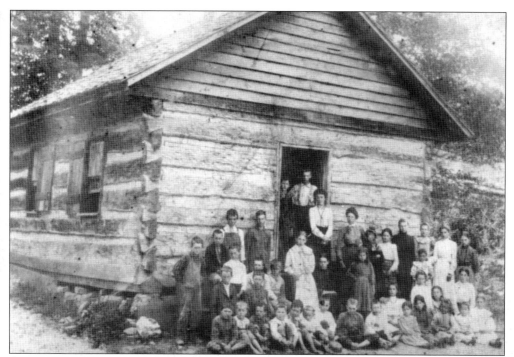

CEDAR BLUFF SCHOOL. This group of Cedar Bluff schoolchildren is posed in front of the first log building that once served as their church and their school. (Courtesy Jack Taylor.)

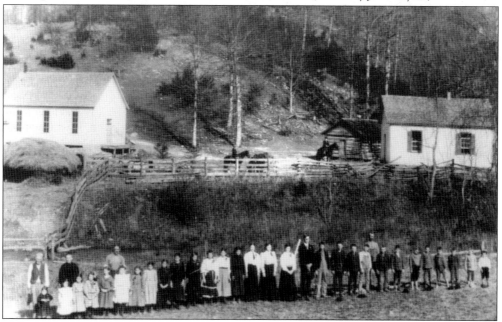

CEDAR BLUFF SCHOOL AND CHURCH. This c. 1900 photograph of Cedar Bluff shows the Cedar Bluff United Methodist Church and early school building on the left. The land for the school and church was donated in 1876 by Samuel and Ann Wright. On the right is the later school building. The school is still standing and is located near the intersection of S.R. 712 and S.R. 713. (Courtesy Jack Taylor.)

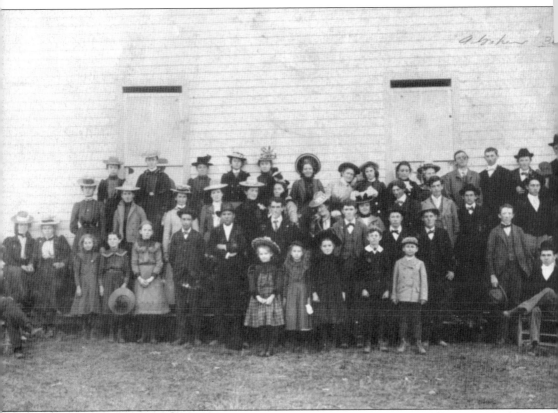

GREEN SPRING ACADEMY. This two-story frame school was located on old Blue Spring Road, now Azure Lane or S.R. 676. Local citizens formed a stockholder group to construct and operate the school about 1897. The school burned after 1911 and was replaced by Green Spring Elementary School. The following people are included in the photograph: ? McCall (assistant teacher), Annie Minnick, Mary McConnell, King Nutty, Chub Smith, Ress Thomas, Gardner Lowry, Alex Lowry, Guy McConnell, Prof. S. W. Edmondson, Willie Lowry, Hattie Minnick, Mary Minnick, Margie McConnell, Maud Lowry, Blanch Hope, Kate Gray (music teacher), Will Hope, Frank Clark, Jim McChesney, John Parks, Ethel McChesney, Maggie Lee Carpenter, Eva Smith, Linnie McChesney, Rebecca Hope, Sally Thomas, Etta Lowry, Kate Nutty, Rose McConnell, Hope McConnell, Frank Gray, John Minnick, and Lloyd Cox. (Courtesy Tom McConnell.)

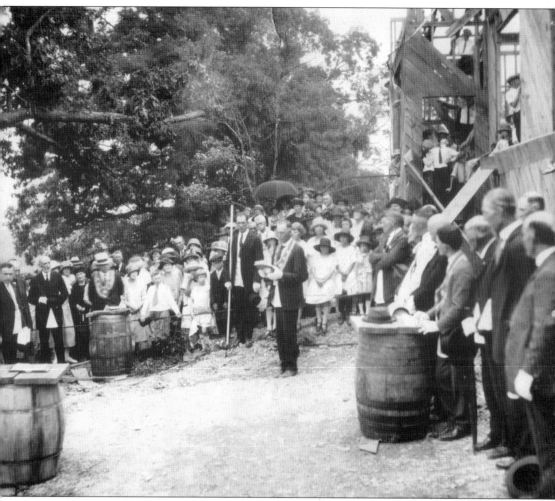

CORNERSTONE CEREMONY. On August 15, 1923, the cornerstone for the Green Spring Presbyterian Church was laid and a regal ceremony was conducted by the Abingdon Masonic Lodge No. 48. The Masons in the ceremony are wearing special collars and white gloves. This occasion was obviously a joyous, important event for the community. This brick church was the fourth one for the Green Spring congregation, which was organized about 1781. The church is still active today. The Green Spring area was named for green pebbles found in a stream. (Courtesy Nancy Gray Lowry.)

Green Spring Presbyterian Church Group. Behind this church group is the early frame church, which burned on October 9, 1921. The separate session room is shown in the background. A brick church was built in 1923 and is still standing today. Pictured from left to right are (first row) Lum Baumgardner and Floyd McConnell; (second row) John Clark, Arthur McConnell, Jim Lowry, Adam Shaun, Ed Browning, Alex Lowry, and Doc Shaun. (Courtesy Nancy Gray Lowry.)

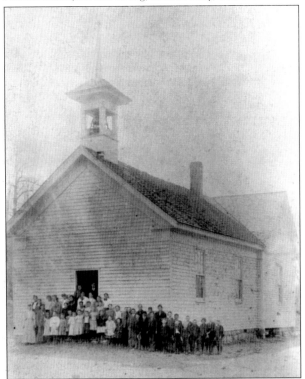

Barrack's School. This frame building is likely the second Barrack's Institute building and stood behind the current brick building's location in the Loves Mill community. Note the wood shingles on the roof. (Courtesy Debbie Wilkinson Tuell.)

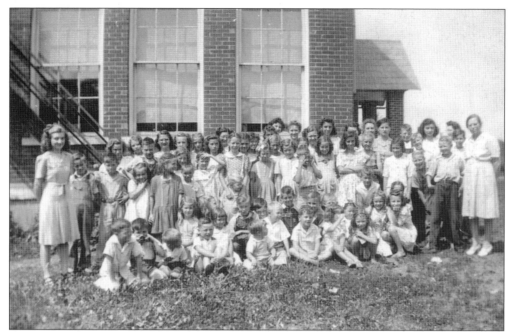

BARRACK'S INSTITUTE. The teachers in this *c.* 1940 Barrack's Institute photograph are Fern Cole Blevins on the left and Nannie St. John on the right. Although preceded by an earlier log school (mid-1800s) and a frame school building, the brick Barrack's Institute building was built *c.* 1914. It is still standing in the Loves Mill community. (Courtesy Debbie Wilkinson Tuell.)

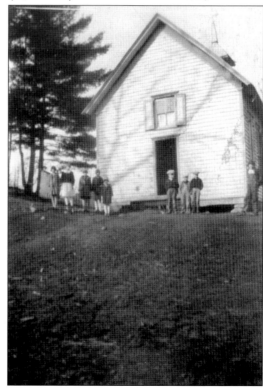

BEECH GROVE SCHOOL. The one-room Beech Grove School was located on S.R. 605, Widener's Valley Road. This photograph appears to have been taken *c.* 1920. (Courtesy Howard Davis.)

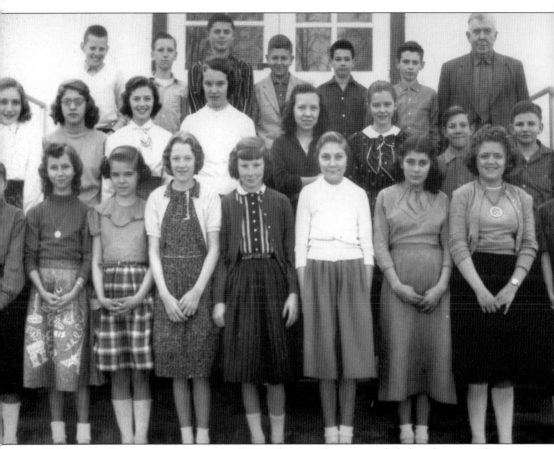

PLASTERCO ELEMENTARY SCHOOL, 1957. These students attended the Plasterco Elementary School in 1957. Pictured from left to right are (first row) Lilly Badger, Jody Athey, Margaret Galliher, Frances Henderson, Linda Tolbert, Velma Moore, Elsa Holmes, Linda Vaught, and Peggy Grady; (second row) Patsy Rector, Joann Bordwine, Elizabeth Ann Poston, Revonda Elmore, Jettie Adams, Jewell Smith, Alton Prater, and Jimmy Counts; (third row) Douglas Pierce, Ronnie Offield, Douglas Johnson, Jimmy Bordwine, Johnny Boyd, Jimmy Farris, and J. Sanders Farris (teacher). Students not pictured are Jerry Helton and Coy Nunley. (Courtesy MOMA.)

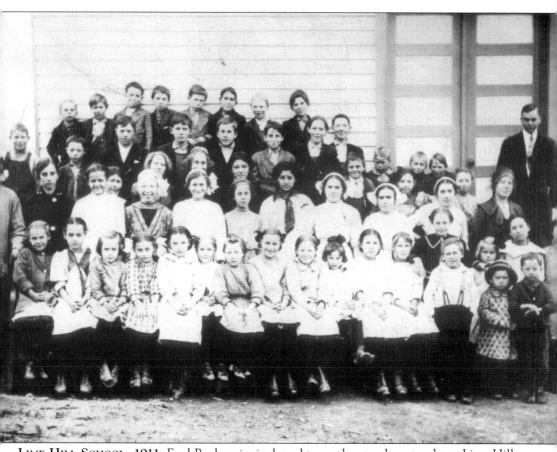

LIME HILL SCHOOL, 1911. Fred Buck, principal, and two other teachers taught at Lime Hill School. Included here are Ruth Keesee O'Dell, Nora Shaffer, Lillis Shaffer, Jewel Leonard, Mary Hill Miller, Ruby Morgan Necessary, Iva Murray Shaffer, Ona Lee Sharrett Hendricks, Ethel Weatherly, Elvie Bays Beam, Joanna Shaffer Murray, Zula Kaylor Ryan, Bertie Leonard Bays, Ward Davidson, Jane Sharrett Spahr, Joe Stratton, Etna Stratton, Willie Fleenor Smith, Ellen Shaffer, Victoria Stratton, Beula Barker, Pearl Fleenor Leonard, Jennie Smith Cotter, Joan Fleenor Kegley, Mittie Shaffer Davidson, Minnie Shaffer Thomas, Hattie Fleenor Thomas, Esther Smith, Estel Murray Leonard, Ethel Morgan Barker, Audra Fleenor Hawley, Melvin Shaffer, Jim Shaffer, Coy Bays, Dewey Shaffer, Isaac Barker, Curt Keesee, Baxter Shaffer, Dewey Bays, Shine Denton, Pierce Weatherly, Webster Kaylor, Dennis Sharrett, Clarence Fleenor, Baxter Barker, Lawrence Fleenor, Jim Tom Fouch, Ben Rush, Hop Rush, Carl Fleenor, Howard Leonard, and Jess Fleenor. (Courtesy Joe Smith.)

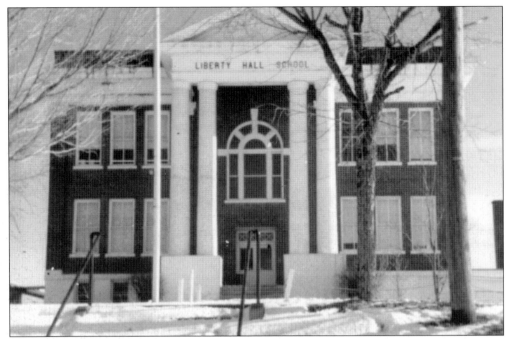

LIBERTY HALL SCHOOL. Founded in 1866 by Rev. James Keys, the Liberty Hall School was used for a school until 1915 in the Lodi community. Unfortunately it now stands dilapidated and has not been maintained or repaired. (Courtesy Ida Mae McVey.)

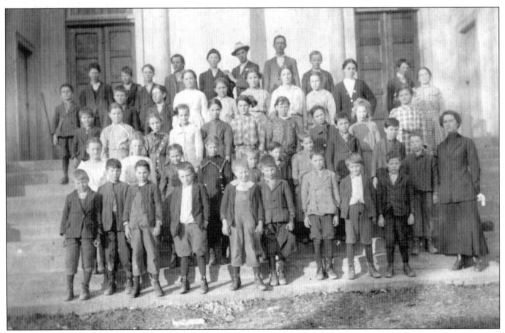

FRIENDSHIP SCHOOL. Students of Friendship School stand on the steps of the Friendship Baptist Church, where they attended classes. Most of the children are unidentified except for Amasia Robinson, on the second row, second person from the left; and Mabel Crowe on the third row, 10th person from the left. (Courtesy Howard Davis.)

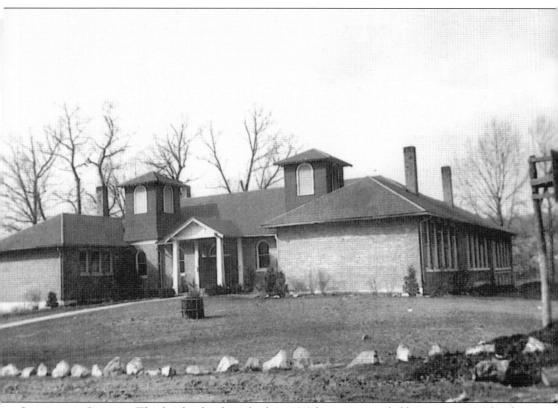

CLEVELAND SCHOOL. This brick school was built in 1917 but was preceded by a one-room school built in 1891 and a frame school built in 1902. Cleveland School was located on Cleveland Church Road in the King's Mill community. Rooms were added to the 1917 school in 1923, 1948, 1953, and 1958. In 1978, the doors were closed, and it burned in 1983. The shop building, built as a Works Progress Administration project in the late 1930s, remains on the site. The school was a center for this closely knit community, and a neighborhood group is working to develop a community center in the shop building. (Courtesy Lewis Berry Garrett.)

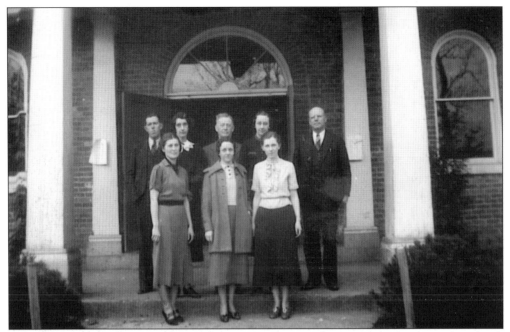

CLEVELAND SCHOOL FACULTY, 1938. This early photograph pictures the faculty at the school. Pictured from left to right are (first row) Mary Mast, Inez McChesney, and Ruth Berry; (second row) P. R. Fisher, Mrs. W. G. Booher, A. W. Carmack (the principal), Evalyn Barker, and C. A Jones. (Courtesy Lewis Berry Garrett.)

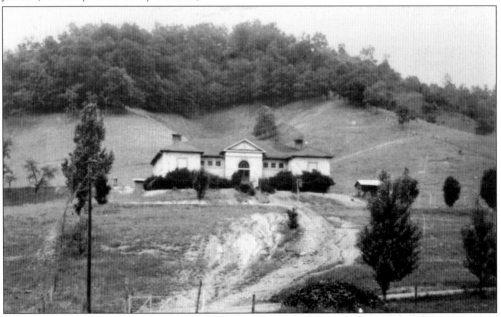

VALLEY INSTITUTE IN 1948. The first Valley Institute was built in 1911, although three one-room schools—Mount Tabor, Oak Hill, and Carsons—served this area outside Bristol before that. This building shown was completed in 1957 and contained 14 classrooms, a library, kitchen, offices, and a clinic. The boys' outhouse is behind the coal house on the right, and the girls' outhouse is visible on the left of the school. (Courtesy Joe Smith.)

VALLEY INSTITUTE CLASS OF 1947. This 1947 graduating class is posed on the steps of the older Valley Institute. Pictured from left to right are (first row) Mildred Fleenor (teacher), Audrey Sorah, and Faye McCroskey; (second row) Betty Millard, Eugenia Goodman, Don Leonard, Louise Necessary, and Colleen Killoy; (third row) Eddie Miller, Doug Miller, Mary Lou Hensley, and Peggy Shankle; (fourth row) Dewey DeBusk, Benny Sims, Gene Cross, and J. D. Sproles. (Courtesy Joe Smith.)

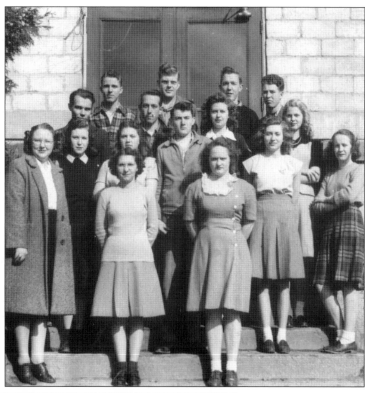

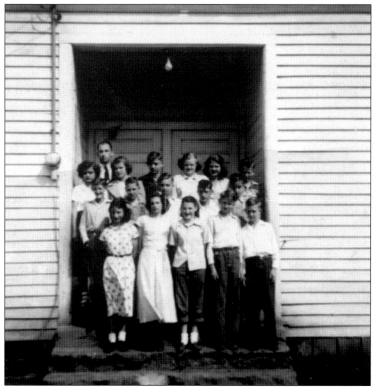

BENHAMS SCHOOL. Benhams School was built in 1934. Pictured from left to right is the seventh-grade class in 1950: (first row) Francis Murray, Bonnie McCracken, Shirley Sproles, Charlie Fleenor, and Allen McCracken; (second row) Wayne McCracken, Lynn Blaylock, Doug McCracken, Dale Mitchem, and Gene Fleenor; (third row) Virginia Fleenor, teacher Jerry Myers, Jean Fleenor, Emory Farlow, Nelma McCracken, Ernest Leonard, and ? Vincill. (Courtesy Joe Smith.)

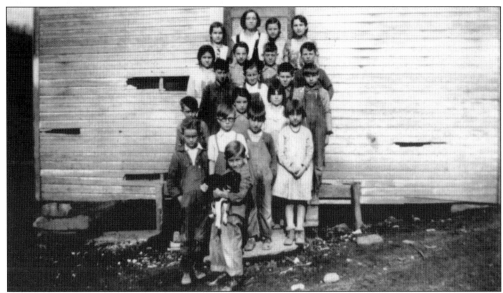

CHINQUAPIN/BUTTERMILK SCHOOL. This school was located on Campground Road. Pictured from left to right are (first row) Charlie Moore; (second row) James Moore, George Sykes, Paul Hill, and Ellen Harr; (third row) Bill Fleming, Nancy Anderson, and Nell Sproles; (fourth row) Andrew Rosenbalm, James Hughes, Johnny Harlow, and Kenneth Hill; (fifth row) Faye Sproles, Helen Hill, Clarence Harr, and Edward Anderson; (sixth row) Louella Moore, Lennie Pitts (teacher), Mattie Kate Hughes, and Anna Lee Moore. (Courtesy Joe Smith.)

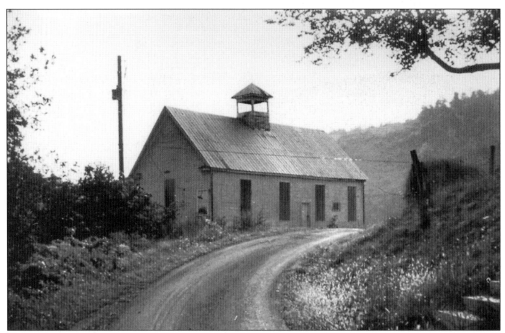

LIBERTY HILL SCHOOL. Located in the Hankel community on S.R. 700, the Liberty Hill School has stood on the hill for many years. It is still standing, although no longer used for a school. (Courtesy MOMA.)

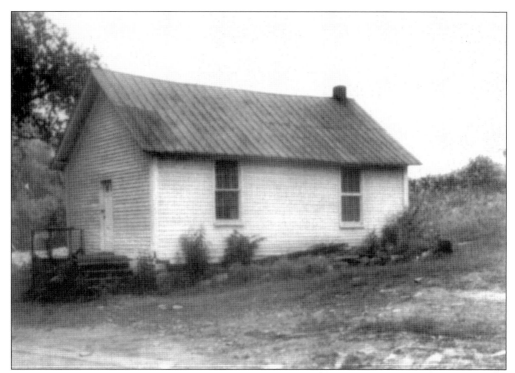

RIVER BRIDGE SCHOOL. The first Hayter's Gap area school was organized in the late 1800s and held in a house above the Hayter's Gap Church. The River Bridge School was located in Hayter's Gap where the River Bridge Church is located today along the North Fork of the Holston River. The school was closed in 1956. (Courtesy Mary Love Johnson Caudill.)

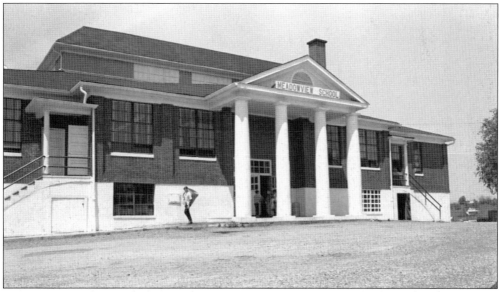

MEADOWVIEW SCHOOL. The Meadowview School was built by local residents in 1923 and contained 14 classrooms, an auditorium, and offices. A newer school was built, and students moved to that school in 1975. This building is now occupied by a furniture store. (Courtesy Lowry Bowman.)

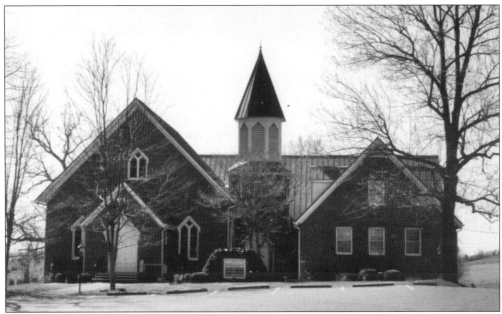

EBBING SPRING PRESBYTERIAN CHURCH. Before 1772, two Presbyterian congregations were active in the county, at Sinking Spring in Abingdon and this one at Ebbing Spring in old Glade Spring. This brick church was built in 1845, replacing an earlier church on the site dating to 1795. A cemetery adjacent to the church is well maintained and is the resting place for many early settlers and their descendants. (Courtesy Donna Akers Warmuth.)

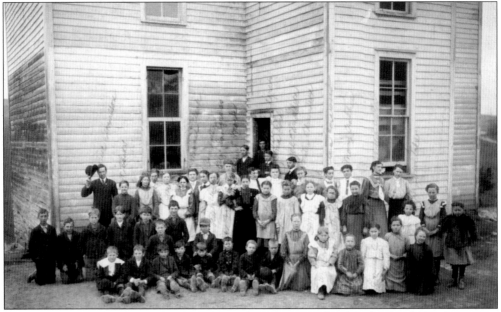

STONE HIGH SCHOOL. This school was located on the east side of Cedar Creek Road, opposite the existing Greenfields Baptist Church. The only identified students are in the third row. From left to right they are Bill Edmondson, ? Witkins, four unidentified, Nannie Clark, Bess ?, Eliza Snodgrass, Curt Mock, Alma Clark, Joe Edmondson, ? Edmondson, Clara ?, Mary Crabtree, and Willie Hutton. (Courtesy Juanita Mock Neese.)

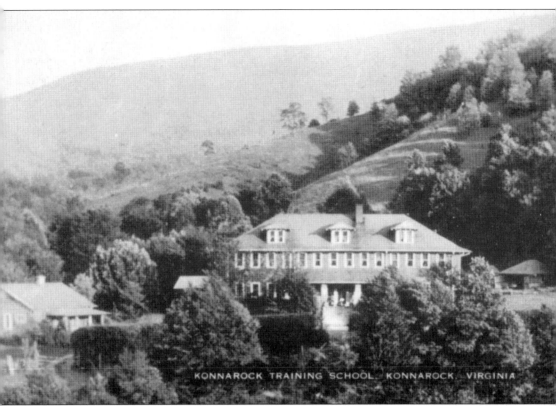

KONNAROCK TRAINING SCHOOL · KONNAROCK · VIRGINIA

KONNAROCK TRAINING SCHOOL. This school was built in 1908 and provided classes for elementary and high school students until 1953, when the older students were sent to Damascus. The Hassinger Lumber Company supplemented the salaries of the teachers at the school in an effort to attract more highly qualified teachers. Early principals were ? App, ? Sudbeth, R. P. Carroll, Guy Hollingsworth, and A. C. Carmack. The school closed in 1964. The earliest school in Konnarock was located near Azen Baptist Church. (Courtesy Dr. Paul Brown.)

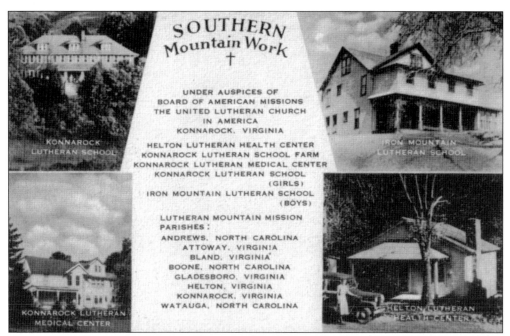

LUTHERAN MOUNTAIN MISSION. The United Lutheran Church included several parishes in the Appalachian Mountains, one of them in Konnarock. The Helton Lutheran Health Center, Konnarock Lutheran School Farm, the Konnarock Lutheran Medical Center, the Konnarock Lutheran School (for girls), and the Iron Mountain Lutheran School (for boys) were part of the mission program. (Courtesy Dr. Paul Brown.)

HAMILTON HIGH SCHOOL. This 1948 photograph shows Hamilton High School, located in Mendota. It opened about 1951 and was closed in 1991 as part of the consolidation. In 1874, Hamilton Institute, an early junior college that attracted students from the region, was begun in Mendota. (Courtesy Joe Smith.)

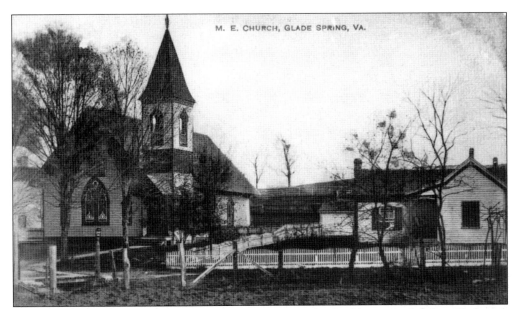

METHODIST EPISCOPAL CHURCH. Built *c.* 1876–1879, this building was the first Methodist church in Glade Spring. John B. Allison donated the land for the church. The church was later taken down and rebuilt near the present-day Ebenezer Methodist Church. A brick building now occupies the lot. (Courtesy Lowry Bowman.)

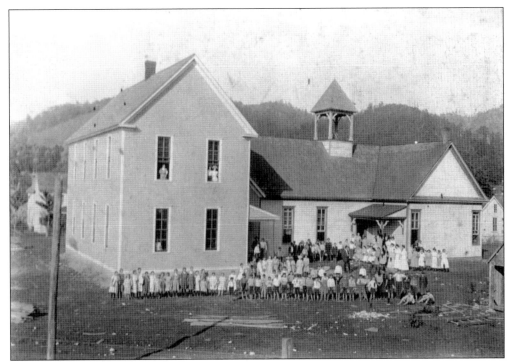

DAMASCUS SCHOOL C. 1910. This photograph shows the rear of the Damascus School building in 1910. It was located on Railroad Avenue. This school was replaced by the Rock School. (Courtesy Louise Fortune Hall.)

DAMASCUS ELEMENTARY SCHOOL. The Damascus Stone School was built from river rocks in 1921, and the entire community helped either to build or fund the project. The land was donated by Clarence A. Backer, who organized the Southport Extract Company. (Courtesy Susie Copenhaver Lang.)

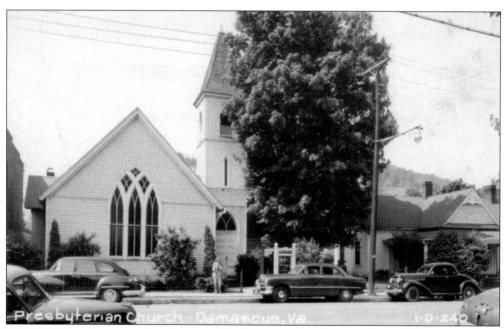

PRESBYTERIAN CHURCH. The Damascus Presbyterian Church was built in 1907 through fund-raising efforts of the Ladies Aid Society. Ellen Legard Wright organized the society of other Presbyterian ladies to raise money to build a church. (Courtesy Louise Fortune Hall.)

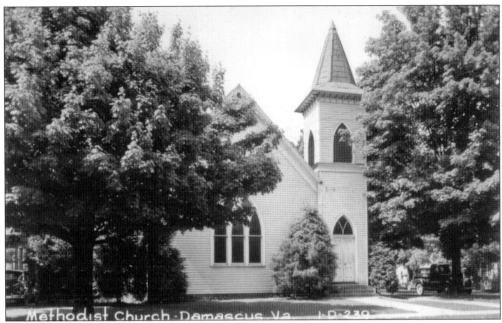

METHODIST CHURCH. The Damascus Methodist Church was built in 1903 on land deeded by the Douglas Land Company. The frame building was demolished in 1948 and replaced with a brick church. (Courtesy Louise Fortune Hall.)

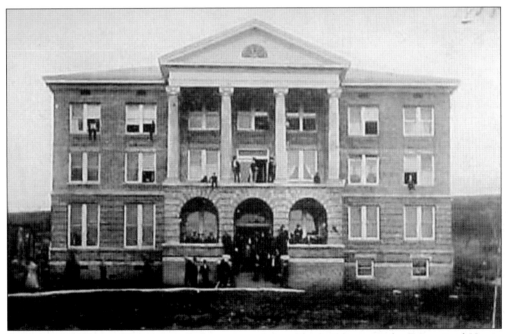

EMORY AND HENRY. This postcard shows one of the older buildings on the Emory and Henry campus, possibly the administration building. Emory and Henry College was established in 1838 in Emory, and the entire campus is listed on the National Register of Historic Places. Their academic program is ranked highly among colleges nationally. (Courtesy Jeffrey Weaver.)

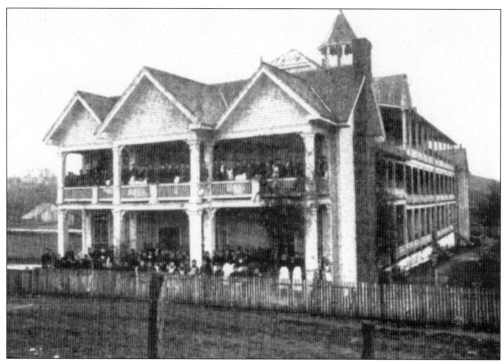

SOUTHWEST VIRGINIA INSTITUTE. Founded in 1884 by Rev. J. R. Harrison, the Southwest Virginia Institute was built in Glade Spring. After burning down, the school was rebuilt as Virginia Institute in Bristol, Virginia, in 1891. The name was later changed to Virginia Intermont, and the college is still operating today. (Courtesy MOMA.)

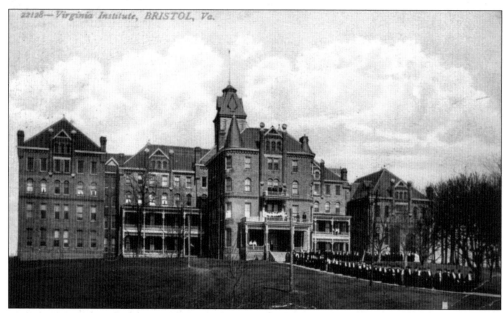

VIRGINIA INSTITUTE. Virginia Intermont, previously known as Virginia Institute, was built on Moore Street, in Bristol, Virginia, in 1891. The school had its beginnings in the Southwest Virginia Institute, pictured above. (Courtesy Lowry Bowman.)

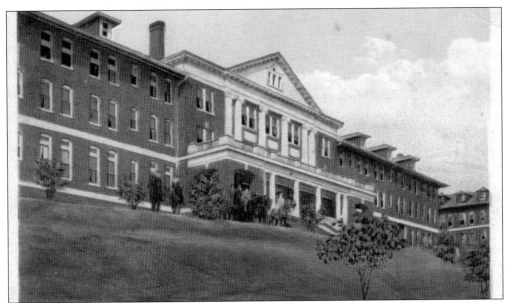

SULLINS COLLEGE. Rev. David Sullins founded Sullins College in 1870. Until 1915, it included not only a college, but a grammar school and high school as well. The school closed in 1977. (Courtesy Donna Akers Warmuth.)

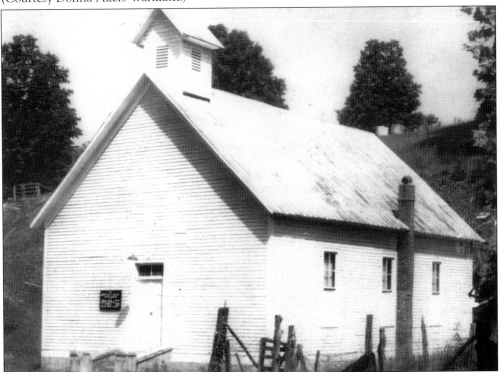

BLACKWELL'S CHAPEL CHURCH C. 1950S. Built in 1903, Blackwell's Chapel Union Methodist Church is located in the Blackwell's Chapel community off S.R. 700 and is still actively used today. John D. and Elizabeth Blackwell sold land for the church for the sum of $1. A cemetery is located nearby. The bell tower was added in the 1920s. (Courtesy Mike Hoback.)

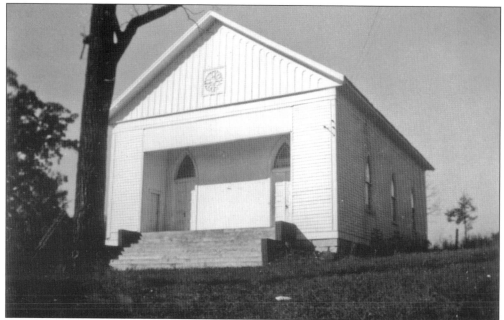

FRIENDSHIP BAPTIST CHURCH. This is the original Friendship Baptist Church building in the Friendship community. The church had two front doors, possibly one for males and one for females. The church was also used for the local school. The church is still standing. (Courtesy Ida Mae McVey.)

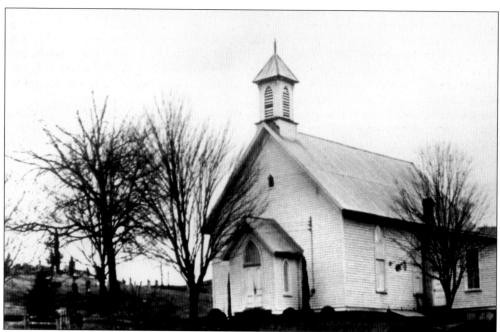

MAHANAIM METHODIST CHURCH. This early frame country church was located in Clinchburg and was founded prior to the town's establishment as a manufacturing town. An earlier log church for the congregation existed in the area. A cemetery is also located adjacent to the church. (Courtesy MOMA.)

Three

BUILDINGS AND HOMES

Settlers needed shelter in this frontier of southwest Virginia, and the abundance of old growth forests provided the timber to build the first log cabins. Several cabins from the late 1700s still exist, and a few have been preserved. Later frame and brick buildings were more common, and many of these still can be found in the landscape. The railroad also provided access to import finer building materials and decorative items. Abingdon, the county seat, has a National Register Historic District of 20 blocks of historic buildings.

Trade took place in local settlements at first but expanded to a national scale after the opening of the Virginia-Carolina Railroad in 1856 in Abingdon. Crossroads communities such as Hayter's Gap soon included general stores, blacksmith shops, and gristmills. Saturdays were commonly market days, and these rural communities were bustling with farmers and shoppers. The railroad and subsequent depots encouraged the development of communities such as Glade Spring, Meadowview, and Damascus. When the rail lines were abandoned, the economies of these communities could not recover. Damascus is the exception since the former Virginia-Carolina Railroad was converted to a pedestrian and bike path known as the Virginia Creeper Trail. As in the past, the town of Abingdon is the main central business location and home to the Washington County Courthouse.

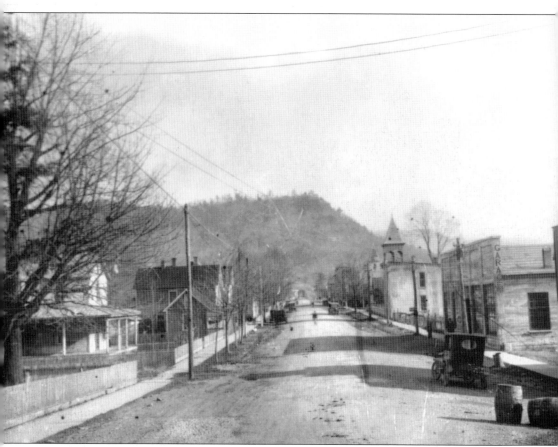

LAUREL AVENUE, C. 1924. This view of Laurel Avenue in Damascus shows several buildings, including on the left the Minton house and Wilson house and on the right side, a garage, the town hall, and the Presbyterian church steeple in the background. Laurel Avenue appears to be a dirt road at this time. The town was first known as Mock's Mill, because of a gristmill built by Henry Mock nearby. The name was changed to Damascus by Gen. J. D. Imboden, who planned to build a "steel city." The iron deposits were not as plentiful as believed, and Imboden's dream of a steel town never came to pass. Imboden's company, the Damascus Enterprise Company, did help to bring the railroad from Abingdon to harvest the timber resources around Damascus. Today commercial buildings have replaced several of the houses in the photograph. (Courtesy Louise Fortune Hall.)

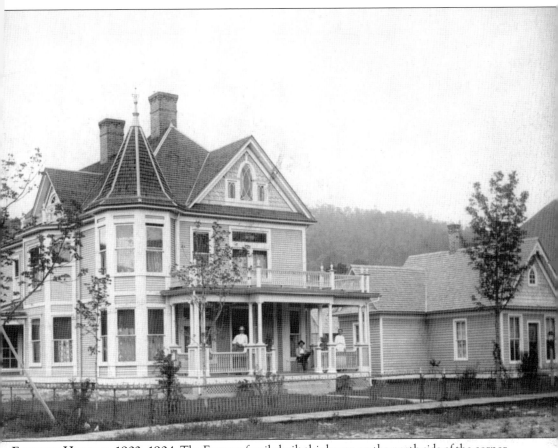

FORTUNE HOUSE C. 1903–1904. The Fortune family built this house on the north side of the corner of Reynolds and Laurel Avenues in Damascus. The house was one of the first two in Damascus with running water and indoor plumbing. Pictured from left to right are Robert Edward Fortune, Richard Franklin Fortune, and Rose Fortune. Robert Fortune was the first doctor in Damascus, and his first office was on the right-hand side of the house. Dr. Fortune practiced in the area for nearly 40 years. Richard Fortune was the first vice president of the Bank of Damascus. In the late 1880s, Capt. William P. Fortune moved from Buncombe County, North Carolina, to engineer the construction of the Abingdon Coal and Iron Railway, which later became the Virginia-Carolina Railroad. The house was demolished in 1963. (Courtesy Louise Fortune Hall.)

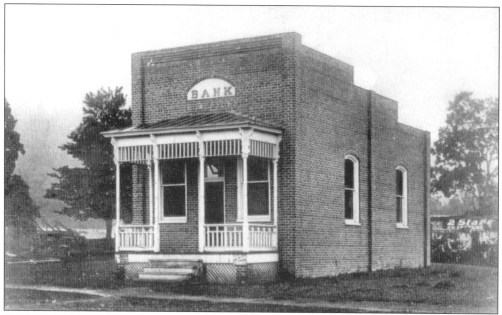

BANK OF DAMASCUS C. 1903. The Bank of Damascus was housed in this building located on the corner of Reynolds and Laurel Avenues. The bank's first location was in a building with the Damascus Land Company in 1901. The bank closed in the Depression in 1933, but it later merged with Meadowview Bank and reopened. Due to this merger, depositors didn't suffer losses during the Depression. (Courtesy Louise Fortune Hall.)

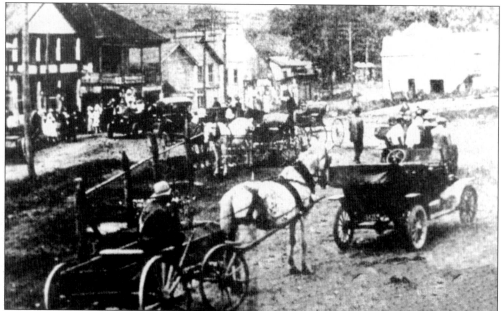

GLADE SPRING, 1911–1920. The automobile on the right side was owned by a Mr. McKinney and said to be one of the first "horseless carriages" in town. The commercial buildings include, from left to right, the Benjamin Curtis house/store (1870–1872), McKinney and Kent and Mason's Storehouses (1880), the Emanuel Rumbley house (c. 1880), and the livery stable. A few individuals are identified in the photograph, including Joe Shew, Tobe Clark, and John Seal. (Courtesy MOMA.)

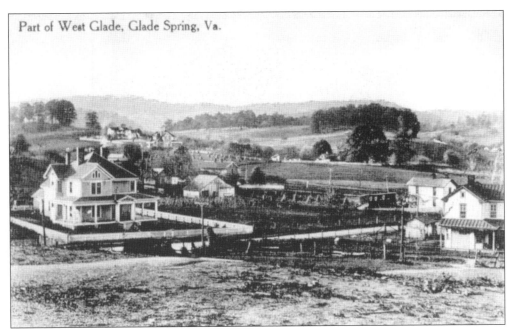

WEST GLADE SPRING. This older view of houses in western Glade Spring portrays the small farms and agrarian nature of the community's past. Haystacks can be seen in the distant field. Electric lines appear to be lining the roads. (Courtesy Ida Mae McVey.)

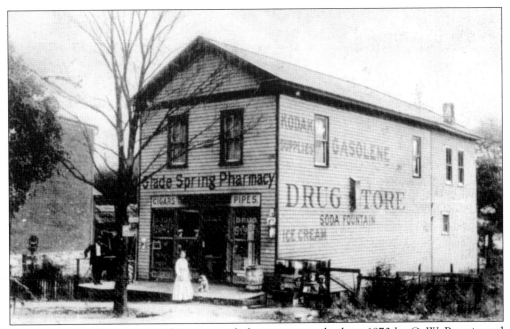

GLADE SPRING PHARMACY. This store and pharmacy were built in 1870 by C. W. Beattie and Minter Jackson. Signs advertising cigars, pipes, ice cream, a soda fountain, Kodak supplies, and "gasolene" reflect customers' needs. (Courtesy Ida Mae McVey.)

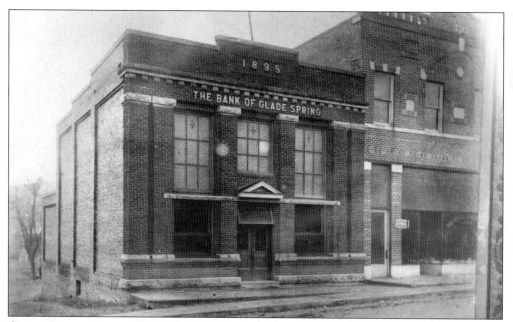

GLADE SPRING BANK. The bank building was built in 1895 in downtown Glade Spring. The building to the right is the storehouse, which became the Farmer's Exchange and later the Holston Furniture Company. (Courtesy Lowry Bowman.)

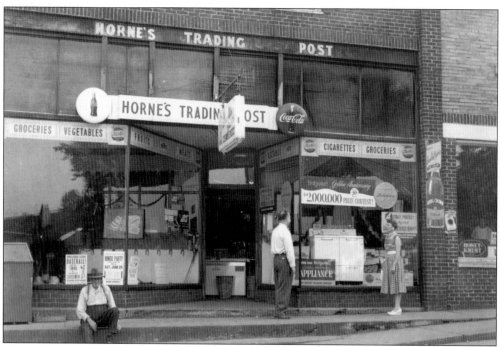

HORNE'S TRADING POST. Located in Glade Spring, Horne's Trading Post was owned by Herbert and Lucille Horne (pictured standing in front of the store). The store was a favorite gathering place for the farmers when they came to town. The building is still standing on the west end of town square and is used for a grocery store. (Courtesy Jerry Ratcliff.)

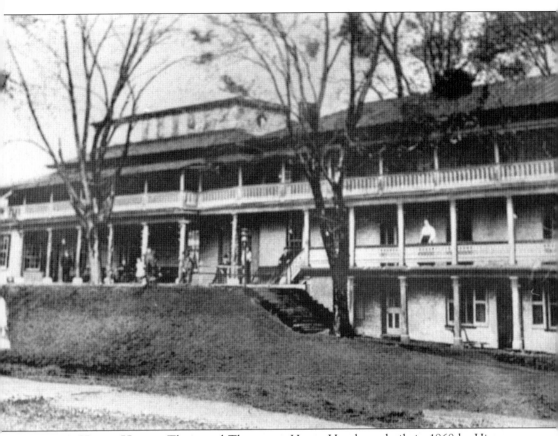

THOMPSON HOUSE HOTEL. The grand Thompson House Hotel was built in 1868 by Hiram V. Thompson near downtown Glade Spring. Advertisements boasted of wide verandas, large airy rooms, and flowered walks. The Thompson House Hotel was advertised as a railway eating house and a hotel for summer boarders, at $2 per day. Some of the boarders were employees of the Mathieson plant in Saltville who would ride the Salt Branch Rail into work. The hotel also served as a social meeting place for local residents. Thompson was an engineer on the Virginia and Tennessee Railroad, and he and his wife also had a catering business. Thompson operated the hotel for almost 30 years. It later passed through several subsequent owners. The hotel is no longer standing. (Courtesy Lowry Bowman.)

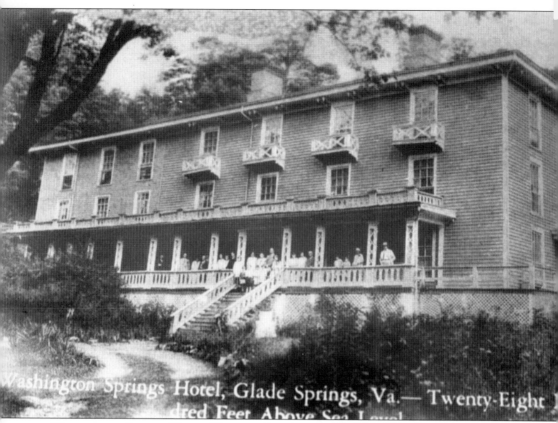

Washington Springs Hotel, Glade Springs, Va. — Twenty-Eight
dred Feet Above Sea Level

WASHINGTON SPRINGS HOTEL. This grand hotel was built by Dr. Edmund Longley in the mid-1800s near Glade Spring. The resort advertised their mineral springs as including sulphur, magnesia, soda iron, iron, alum, and Leech's chalybeate. Dr. Longley advertised the waters as cures for many ailments, and this popular resort provided a swimming pool, tennis courts, bowling alley, dance pavilions, and croquet lawns. Originally the hotel had 20 rooms, and later an addition increased the number to 46. The resort was a popular social gathering place for the locals as well. The resort closed in the 1940s and burned down in 1956. (Courtesy Lowry Bowman.)

KILMAKRONEN. Built in 1776, the limestone two-story house was named after Col. James Patton's ancestral home in Donegal, Ireland. Historically it has been called a fort, but it is unclear if it was built for that purpose or merely used for protection against the Native Americans. The site contains remains of a fortified Native American village and was called Indian Fields. (Courtesy Donna Akers Warmuth.)

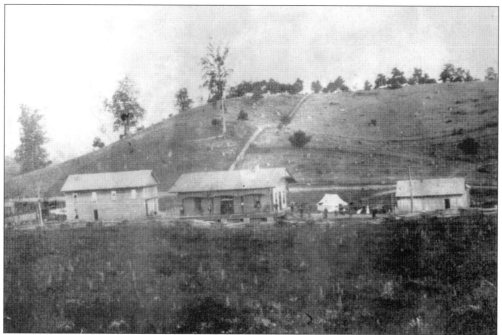

MEADOWVIEW DEPOT. This 1883 photograph shows Meadowview oriented toward the railroad. The depot building is in the middle of the photograph. A tent seems to be set up next to it. The school is not yet built on the hill behind the depot. (Courtesy Phyllis Price.)

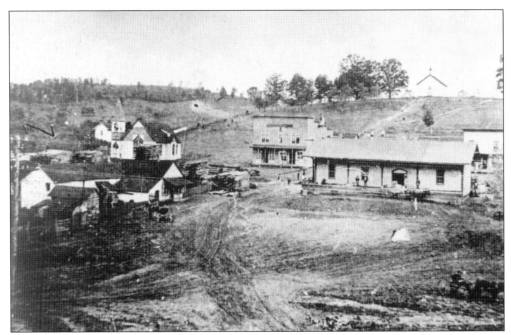

MEADOWVIEW DEPOT, C. 1920. The frame school with steeple (1894) can be seen on the hill, which would indicate this to be a later photograph than the previous one. On the left is the Methodist church (1898) and then the Preston/R. J. Smith Store. The Kendrick Store is located on the east side of the square. (Courtesy Edith Stevens Godbey.)

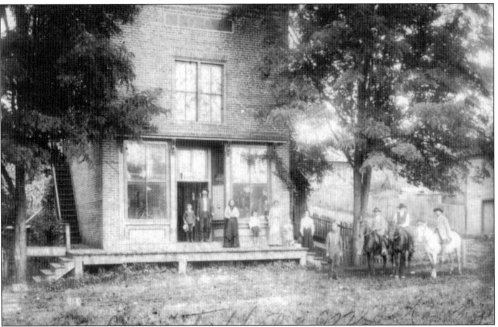

MEADOWVIEW'S POST OFFICE. The post office for Meadowview was housed in the first floor of this brick building for many years. Located on the northern side of the railroad, the building's second floor was occupied by the local Odd Fellows Lodge. The building was demolished about 1950. (Courtesy Edith Stevens Godbey.)

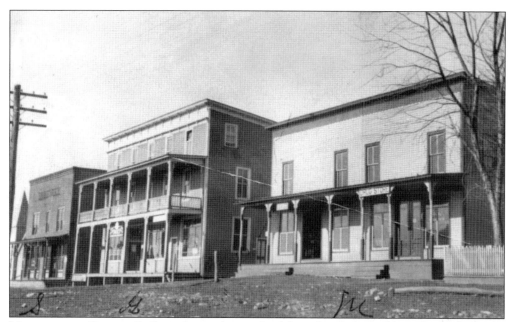

MEADOWVIEW STORES. Built on the northern side of the railroad, the buildings from left to right are the Preston/R. J. Smith Store (1888), which contained a general store until 1929; the A. B. Galliher Store (1909); and Maiden and Son Produce (c. 1903). A hat and clothing store and the County Bank also operated in the buildings. None of the buildings still stand. (Courtesy Edith Stevens Godbey.)

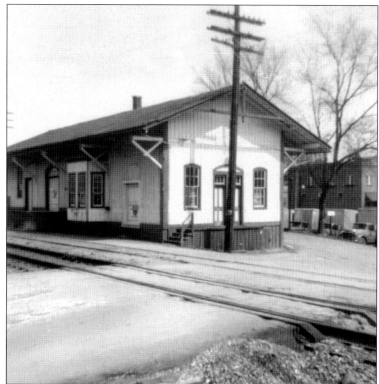

MEADOWVIEW TRAIN DEPOT, 1964. The original train depot was built in 1883. The design was typical of train depot buildings of that period. The town grew and prospered as a train depot. The depot closed as rail traffic declined but remains as a symbol of the town's heyday. (Courtesy Edith Stevens Godbey.)

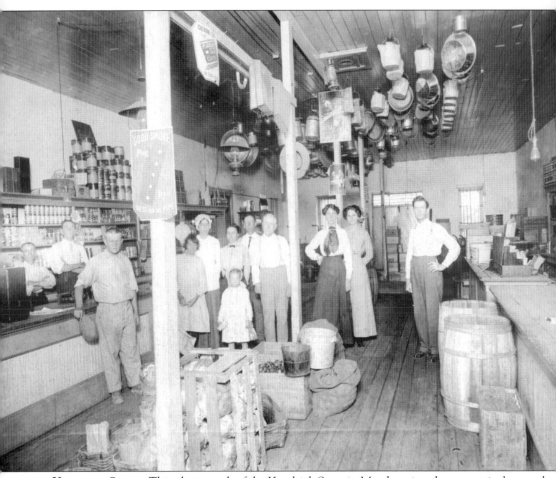

KENDRICK STORE. This photograph of the Kendrick Store in Meadowview shows a typical general store of the late 1800s and early 1900s. Maj. Henry F. and Margaret E. Kendrick constructed a two-story brick building by 1883 with a second floor for residential use just southeast of the depot building in Meadowview. A house was built behind the store about 1895. Note the baskets of produce on the floor and cookware hung on the ceiling. The Kendricks sold the store after 1918, and subsequent owners included C. M. Asbury and G. M. Jackson, T. N. Jessee and H. C. Browning, John H. Bailey, F. O. Parris, and John P. Maiden. The building was later used for a Farmer's Cooperative and a service station. (Courtesy Edith Stevens Godbey.)

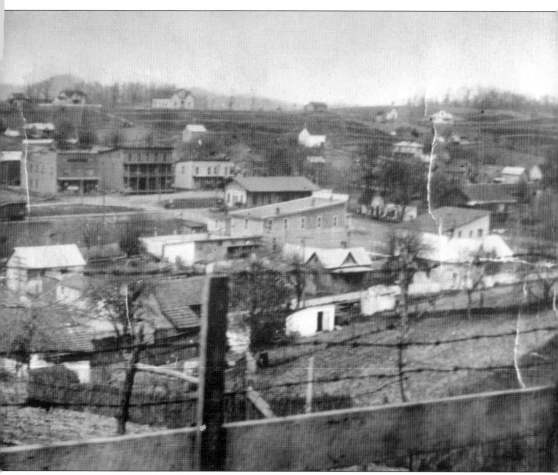

MEADOWVIEW, C. 1909. This early northern view of the town shows the dense development along Depot Square. Shown in the photograph in the background along the railroad opposite the depot are, from left to right, the Preston/R. J. Smith Store, A. B. Galliher Store, and Maiden and Son Produce buildings. The Meadowview Presbyterian Church (*c.* 1886) is the white building on the hill behind these buildings. The depot is the long building parallel to the railroad. The early Kendrick Store is the long, two-story building opposite the depot on the other side of the road. Small homes and outbuildings can be seen in the other areas. (Courtesy Edith Stevens Godbey.)

MEADOWVIEW DEPOT SQUARE, C. 1960S. From left to right along the square, this photograph shows the Francisco building (1920), Maiden Store (1947), the Kendrick/Maiden Building (1921), and the H. B. Maiden and Sons Store (1912/1926). Businesses through the years in these buildings included Maiden's Drug Store, a soda fountain and dress shop, restaurant, laundromat, apartments, post office, and a general merchandise store. (Courtesy Lowry Bowman.)

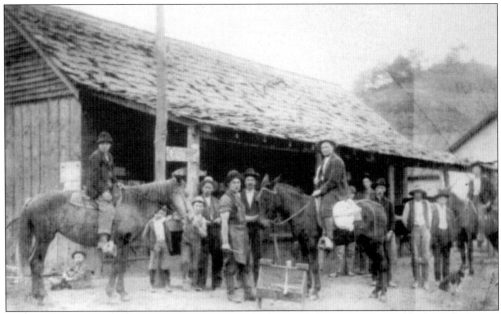

HAYTER'S GAP BLACKSMITH SHOP. The exact location of the Hayter's Gap blacksmith shop is unknown. It was likely near the intersection of Hayter's Gap Road and North Fork Road, near a group of commercial buildings. Saturdays at this crossroads used to be very busy when farmers came to town to trade eggs and butter and shop for staples at the stores of Hayter's Gap. (Courtesy Jack Kestner family.)

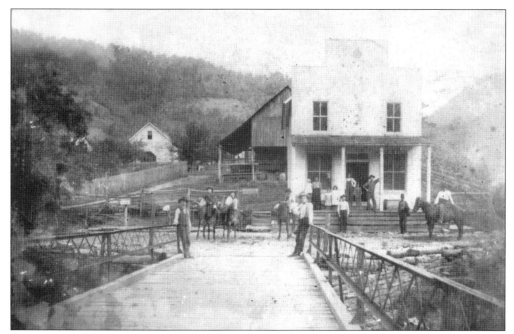

RELAXING ON RIVER BRIDGE. These folks are visiting in the early 1900s in front of the Johnson Store at the River Bridge on the North Fork of the Holston River. The grocery store was operated by Dan Johnson and was torn down after the new bridge was constructed about 1967. (Courtesy Irene Johnson Meade.)

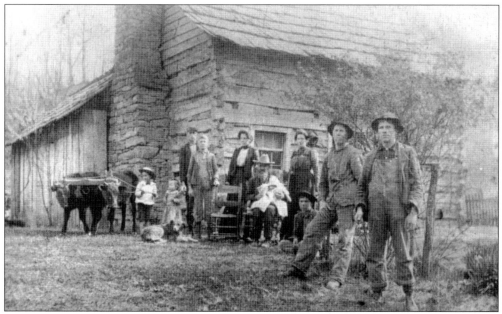

GEORGE JOHNSON HOMEPLACE. This *c.* 1905 photograph shows the Johnson homeplace along the North Fork of the Holston River. Pictured from left to right are Arthur Counts, Garland Counts, John Henry Counts, Elgin Johnson, Lydia Johnson Counts, George W. Johnson holding his grandson Edgar Counts, Lucy Johnson, Joe Johnson, Leroy Johnson, and Jim Johnson. (Courtesy Irene Johnson Meade.)

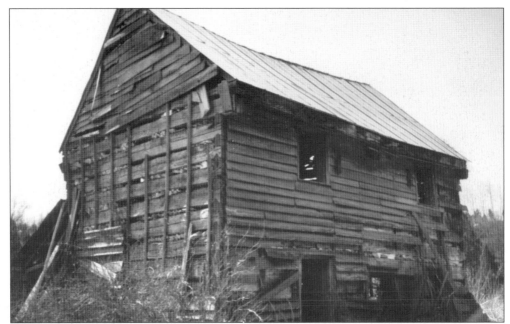

MCCULLOCH CABIN. This log cabin dating to the late 1700s used to be one of the oldest remaining log cabins in the area. Thomas McCulloch built this cabin on the North Fork of the Holston River. Lt. Thomas McCulloch (1736–1780) commanded a company at the Battle of King's Mountain in the Revolutionary War and was mortally wounded. The cabin was demolished a few years ago. (Courtesy Donna Akers Warmuth.)

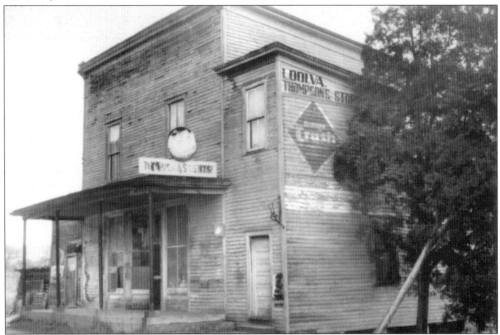

THOMPSON'S STORE. Thompson's Store was a popular gathering spot and shopping destination in the community of Lodi. As the community general store, Thompson's sold food, household items, and other sundries. The building is no longer standing. (Courtesy Susie Copenhaver Lang.)

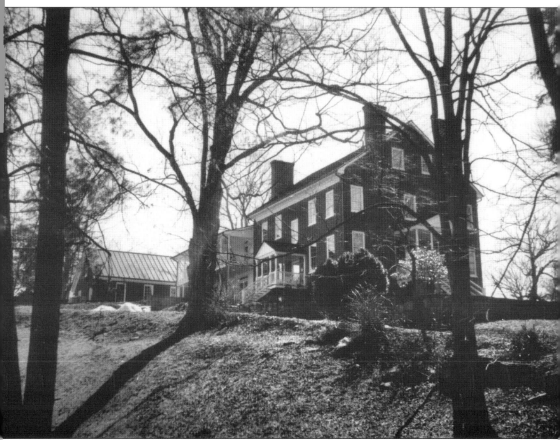

BROOK HALL. Col. William Byars had this grand brick house built *c.* 1826 along U.S. 11, the old Wagon Road. The first Brook Hall was an earlier log house built *c.* 1773, but it is no longer standing. Colonel Byars, a wealthy landowner, designed this grand house with 27 rooms and hired English cabinetmakers to carve the woodwork. Byars was a founder of Emory and Henry College and a colonel in the War of 1812. He also owned a mill, general store, and distillery in the area. Reportedly Andrew Jackson was a guest in the house while traveling to Tennessee. After the Civil War, the Byars family gave the former slaves land from the estate and money to start new lives. Many of the African Americans stayed on the land near the house, and some of their descendants still live there today. Through the years, the house began to show its age, but fortunately the current property owners have restored Brook Hall to its former beauty. This house is a unique historic building in the county. (Courtesy Donna Akers Warmuth.)

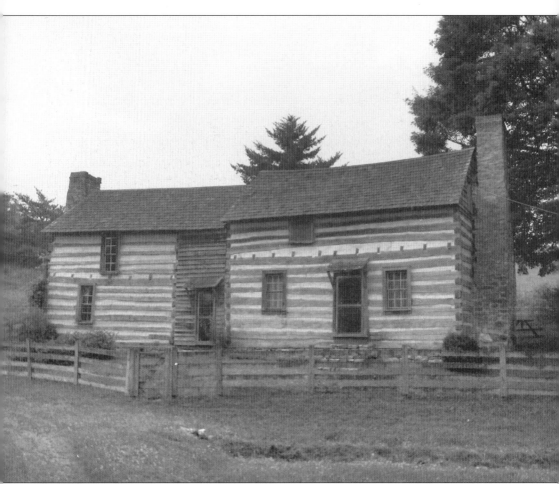

EDMONDSON CABIN. Located in Friendship, this well-preserved log cabin was built by Moses Edmondson in the late 1700s with two stories, including a kitchen and upstairs loom room. In the early 1800s, several bedrooms and a parlor were built on. The large fireplace provides ample room for cooking and has retained the iron hooks for that purpose. The log barn, springhouse, and other outbuildings have also been preserved on site. Most of the furniture and furnishings have been handed down through the Edmondson family. The cabin was restored a few years ago and appears as if frozen in the frontier days. The owner has lovingly preserved it as an authentic representation of her farming family's life. It is unique because few log cabins from this early settlement time remain standing and even fewer in such excellent condition. (Courtesy Donna Akers Warmuth.)

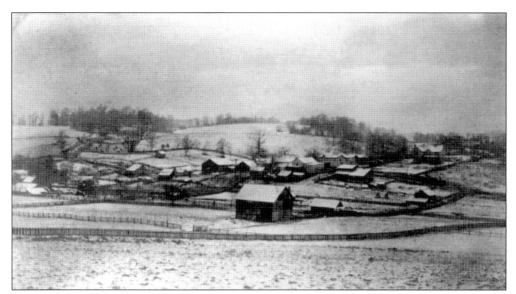

FRIENDSHIP COMMUNITY. Snow covers the fields in this view of the Friendship community. A post office was located in the area from about 1876 until about 1906. The numerous barns and outbuildings give a strong sense of the area's agricultural past. (Courtesy Ida Mae McVey.)

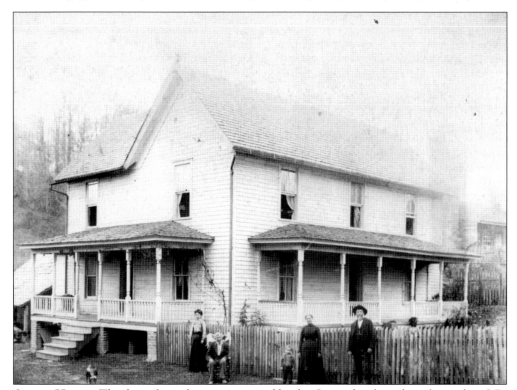

CROWE HOUSE. This large frame house was owned by the Crowe family and was located on S.R. 714 or Price's Bridge Road in the Friendship community. Pictured from left to right are Carrie Crowe Mountain, James DeBusk, Clarence St. John, Mrs. ? Crowe, and J. C. Crowe. (Courtesy Howard Davis.)

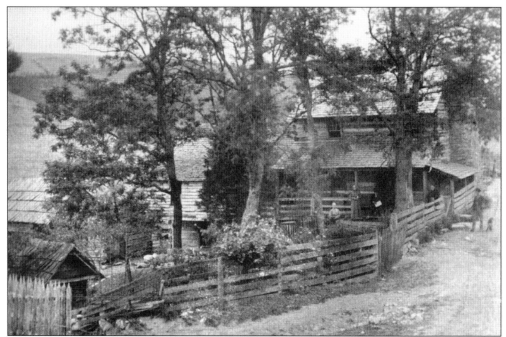

LEWIS COLLEY LOG CABIN. The Colley log cabin was located on the north side of Old Saltworks Road or S.R. 740. For the time period, the structure was quite a large cabin. Only a small part of the building is still standing. (Courtesy Harry Minnick.)

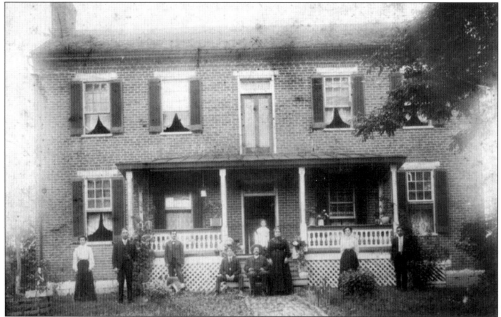

MINNICK/BAILEY HOUSE. James Bailey constructed this farmhouse along Old Saltworks Road about 1850. From left to right are Bessie Minnick, Tommy Richard Minnick, W. J. Minnick, John Minnick (a brakeman on the Virginia Creeper train who died in a Damascus railroad accident), William F. Minnick, Mabel Minnick (behind William), Susan Agnes Hawthorne, Ida Minnick, and Ewell Lee Minnick. Sadly the house has deteriorated through the years. (Courtesy Harry Minnick.)

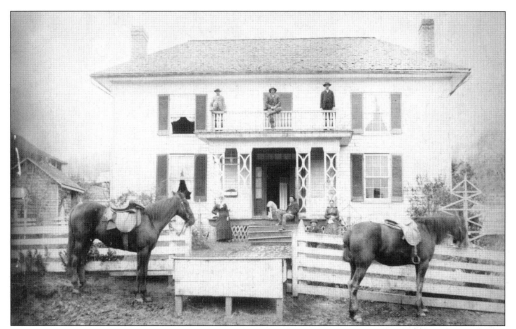

GRAHAM-PRESTON HOUSE. This home was built in 1870 by George and Rebecca Preston Graham and is located on Rivermont Drive or S.R. 706 near the Middle Fork Bridge. In the photograph, George Preston Graham is seated on the porch. The farm originally contained about 600 acres. Today the third-generation descendants of the Grahams, Robert Grey Preston Jr. and Marilou Hall Preston, live in the house and operate the farm. (Courtesy Marilou Hall Preston.)

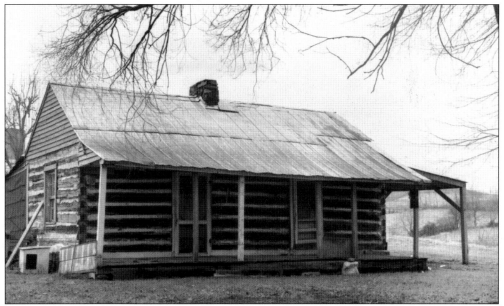

REV. CHARLES CUMMINGS'S CABIN. This cabin of Parson Cummings was built about 1773 and is shown in its original location in the county. Reverend Cummings was known as the "Fightin' Parson" and was said to have carried a rifle to the pulpit. The building was later moved to the Sinking Spring cemetery and located near the site of this Presbyterian congregation's early log church. (Courtesy Lowry Bowman.)

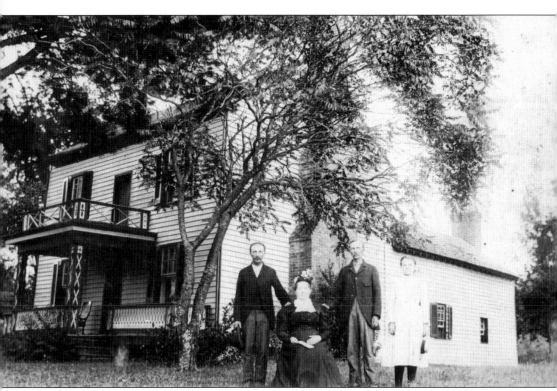

FAIRVIEW/HAGY HOUSE. Pictured from left to right in this *c.* 1898 photograph are Jim Hagy, Mary Hagy, William Hagy, and Alma Clark. The Hagy family was a major landowner in the area between Emory and Abingdon. This frame house covers an earlier log cabin, which dates back to the late 1700s or early 1800s. The house still stands along present-day Hillman Highway a few miles outside Abingdon. Several outbuildings remain on the property. It has been acquired by the Town of Abingdon to establish an agricultural museum. The frame cladding is being carefully removed from the house, and the large log house will be restored. (Courtesy Juanita Mock Neese.)

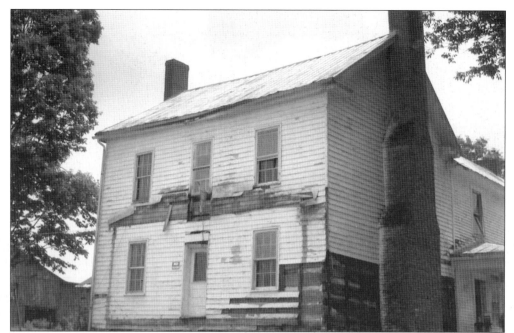

HAGY HOUSE. The frame cladding of the previous Hagy house, known as Fairview, is being stripped off to reveal the log house underneath. The town of Abingdon has acquired the house and plans to restore it as a museum. Some of the logs in the house measure 20 feet long and are the longest observed in early log homes of the region. (Courtesy Donna Akers Warmuth).

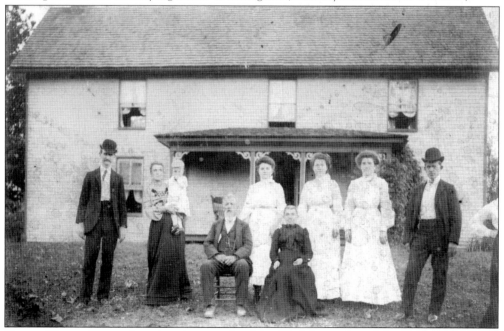

CLARK HOUSE. Pictured in this photograph of the Clark house from left to right are (seated) Pleasant D. Clark and Margaret Susanna Hagy Clark; (standing) Walter Clark; his wife, Susie Clark; their unidentified child; Alma Clark; Nannie Clark; May Clark; and Will Clark. Note the ornate detailing on the porch supports. The house is still standing. (Courtesy Juanita Mock Neese.)

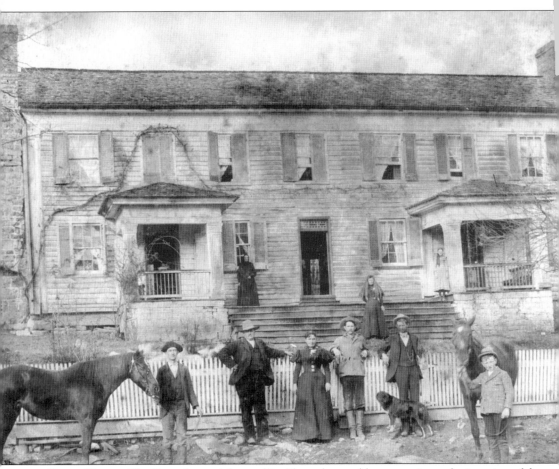

DUNN HOUSE. The Dunn house is located in Alvarado, an old community at the junction of the South Fork and Middle Fork of the Holston River. The earliest land grants go back to the Duff family in 1785 for 400 acres along the river. Hugh Neely planned a town named Carrickafurgus (an ancient capital of Ulster in Ireland) for this location, and the plat included lots, churches, and a school. The town never was developed. The Capt. William Duff family built the house, quite a large house for that time period. Pictured from left to right are (first row) Dave Clark, Henry Preston Clark, Rhoda Campbell Clark, Felix Gray, Frank Duff, and an unidentified person holding a horse; (second row) Ann Elizabeth Spraker Ketron Duff, Kate Zart (housekeeper), and unidentified girl with long hair. During the logging boom, loggers from the Hassinger Lumber Company were boarders at this house, so it is sometimes referred to as the Alvarado Hotel. (Courtesy Gerald C. Henninger.)

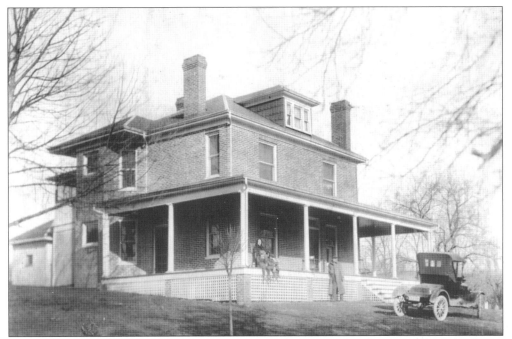

R. K. LOWRY SR. HOUSE. Robert Keller Lowry and Bessie M. Ritchie Lowry had this house built in 1915. Mr. Lowry was a farmer and worked in real estate. This early-20th-century brick farmhouse is still standing and is occupied by the seventh generation of the Lowry family to live at the site. (Courtesy Nancy Gray Lowry.)

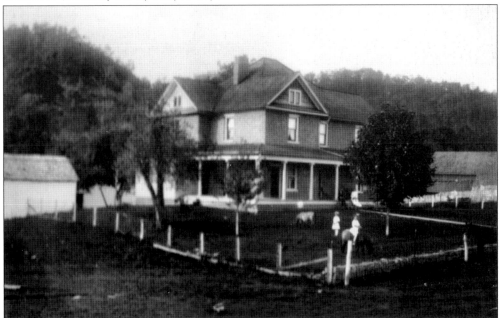

ROBERT BERRY HOUSE. This two-story brick house was built in the Cleveland community in 1911 by Susan and Robert Berry. This architectural style was typical for successful farmers in the early 1900s. The bricks were made from clay on the farm. The well-preserved house remains in the same family today. (Courtesy Lewis Berry Garrett.)

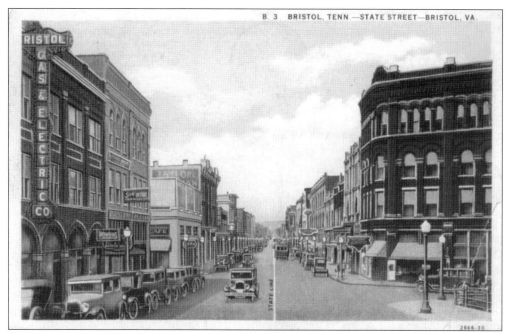

BRISTOL, TENNESSEE AND VIRGINIA. This early postcard shows the imaginary line on State Street through downtown Bristol, Tennessee and Virginia. This unusual political arrangement inspired the famous sign over State Street that reads, "Bristol Va Tenn A Good Place to Live." Note the streetlights, old cars, and the sign for the Bristol Gas and Electric Company. (Courtesy Donna Akers Warmuth.)

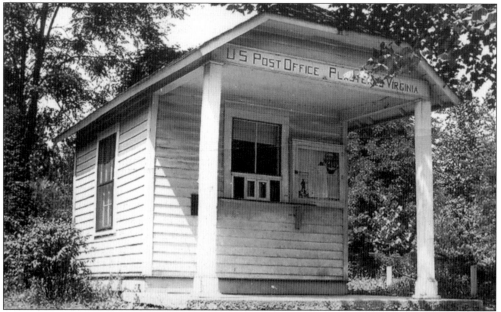

PLASTERCO POST OFFICE. The U.S. Post Office in Plasterco was a "walk through" office with room inside for staff only. Mary E. Holmes was the postmaster there for many years. The office delivered mail to the residents of Plasterco, McHenry Creek, and some areas of Saltville. It was one of the smallest freestanding post offices in the nation. (Courtesy MOMA.)

Four

WORK AND INDUSTRY

Gristmills and sawmills were among the first industries and buildings constructed to meet the settlers' needs. Boyd's Map of 1892 listed 35 mills operating in the county. The community mills were often social meeting spots, polling locations, and post offices. With the development of other sources of power, the need for local mills decreased and most of them closed. Only two mills in the county, White's Mill and J. R. Wilkinson and Sons Mill, still grind grain.

The railroad drove much of the development of industry in the region. The Virginia and Tennessee Railroad extended from Lynchburg to Abingdon by 1856 and extended to Bristol later that year. In 1900, the Virginia-Carolina Railway completed a line to Damascus. By 1911, the Norfolk and Western Railway began to buy out the Virginia-Carolina and later extended the rail line to Elkland, North Carolina. Soon after the rail lines were extended, lumber companies owned by Northern industrialists came to harvest the trees. The lumber boom lasted almost 25 years. According to the 1912 issue of the *National Lumber Magazine*, Washington County produced more lumber than the state of Pennsylvania. Woodworking plants, extract plants, and sawmills grew up close by and employed hundreds of men in the area.

As the lumber was depleted and sawmills closed, the main product for the railroads disappeared. Mail and passenger service was discontinued in 1962. The contributions to the economy were considerable, but the environmental degradation of clear cutting added to erosion and flooding. In 1972, Norfolk and Western abandoned the tracks, and they were later removed. In 1982, the Town of Abingdon acquired the right-of-way for the line to Damascus and up to Whitetop and established the Virginia Creeper Trail for pedestrians and bicyclists.

The lumber industry and railroads did bring a short time of relative prosperity to the area. But after the timber resources were exhausted, the railway lines into the mountains were abandoned. Today the new growths have covered the mountaintops, but selective timbering recently has begun again on some of the hills around Damascus.

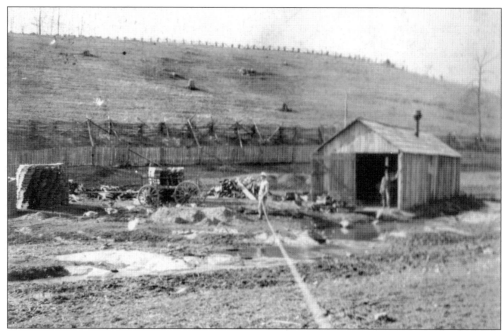

FRANK MINNICK FARM. This *c.* 1910 photograph shows the shingle factory on the Frank Minnick farm located on Old Saltworks Road or S.R. 740. Tom Minnick is standing in the doorway of the building. The line and string in the front of the photograph are attached to the camera that Graham Roberts, a local farmer and photographer, used to take photographs. (Courtesy Harry Minnick.)

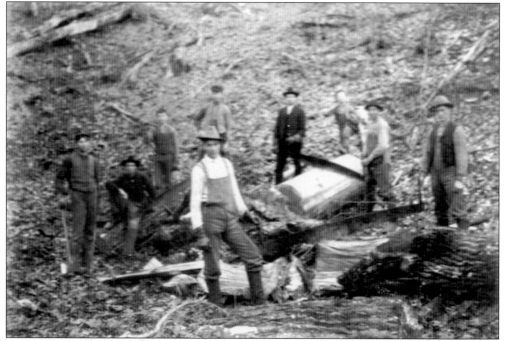

CUTTING TIMBER. These men are cutting timber at the Minnick farm on Old Saltworks Road or S.R. 740. The wood may have been used in the shingle factory on the farm. Several of the men are using crosscut saws. (Courtesy Harry Minnick.)

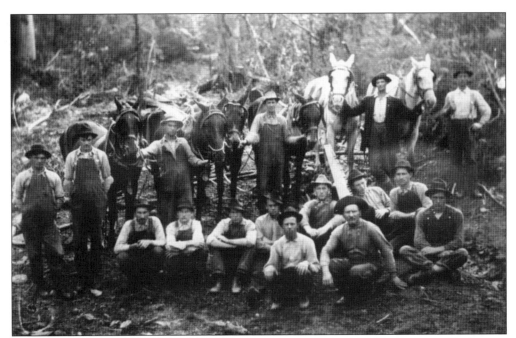

LUMBERING CREW. This early-1900s lumbering crew was a common sight in its time. Timber was a major export of the area, and railroads were built into the forests to transport the timber out. At least three and a half billion feet of lumber was cut from the mountains, much of it from the Damascus area. (Courtesy Lowry Bowman.)

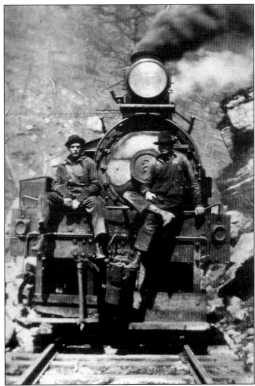

HOLSTON RIVER LUMBER COMPANY TRAIN. Located in Clinchburg, the rail crossed the North Fork of the Holston and continued up Tumbling Creek to the top of Clinch Mountain. It connected to the Salt Branch line, which continued to Glade Spring. Pictured are engineer Andy Pierce (left) and Luther Hamilton on engine No. 2 in this *c.* 1920 photograph. (Courtesy MOMA.)

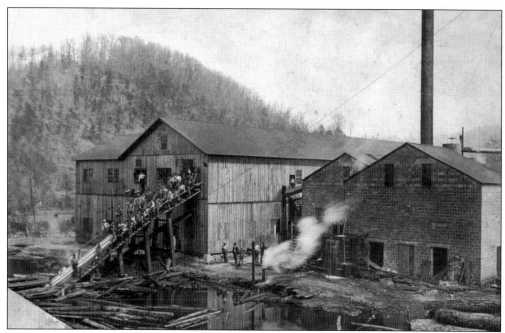

DAMASCUS BANDMILL, 1910. H. E. Clark and J. W. McCullough formed the Damascus Lumber Company in 1906 and bought the bandmill from the Thayer Company. The Damascus Lumber Company cut 18–21 million feet of lumber annually until a fire destroyed the plant in 1921. The building was located at the current location of Food City on U.S. 58. (Courtesy Louise Fortune Hall.)

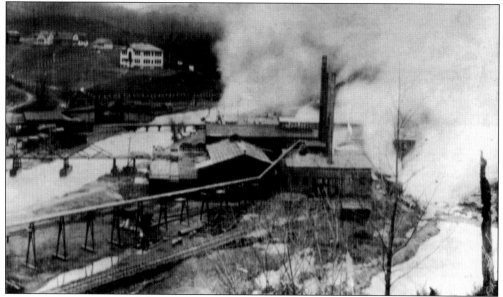

HASSINGER LUMBER COMPANY, 1916. This lumber company established a company town in Konnarock in 1906, which included a company store, hotel, a mill, and 2,000 residents. The large scale of the timber operation is clearly visible in this photograph. After the timber boom, the town became a small residential community, which is adjacent to the Mount Rogers National Recreation Area. (Courtesy Dr. Paul Brown.)

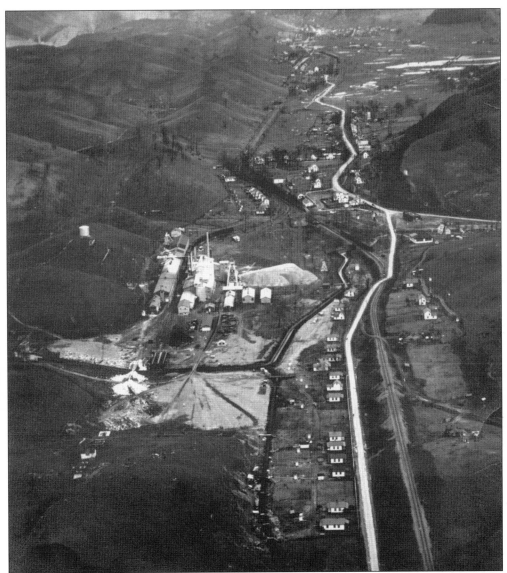

PLASTERCO AERIAL, C. 1940. This aerial shows the town of Plasterco, which was home to the Buena Vista Plaster Mining Company from 1808 through 1908. Buena Vista was the name of salt magnate William King's estate. U.S. Gypsum leased and later purchased the property and produced wallboard until 2000. It was believed to be the deepest gypsum mine in the world. The U.S. Gypsum mines are on the left of the photograph, and the railroad line leads into Saltville. Worker housing can be seen along the highway. These long-term industries provided many jobs in the community and haven't been replaced in the economy. (Courtesy MOMA.)

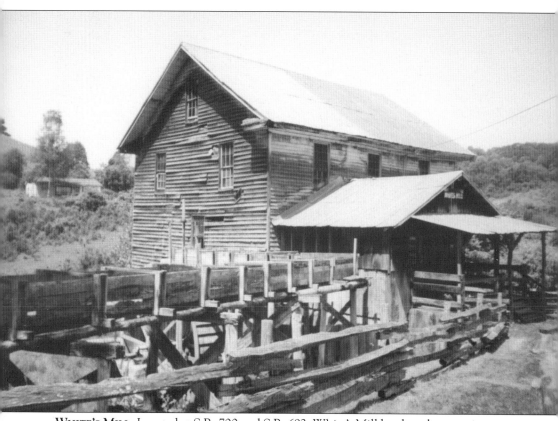

WHITE'S MILL. Located at S.R. 700 and S.R. 692, White's Mill has long been an important part of the county's economy. Although a mill was on the site by 1796, most historians agree that the existing mill wasn't built until the mid-1800s. John Lewark, a Welshman, is credited with making the wooden wheel, the shaft, and the wooden gears. It was originally designed as a water-powered buhr (or millstone) mill with two runs of millstones. However, later changes included a new metal wheel, roller mills, and bolting and sifting machinery. The corner fireplace is still located in the corner of the lower floor. A dutch door, with upper and lower sections that open separately, is still intact and was used to keep the hogs out of the buildings. The mill also served as a voting poll and community gathering place. The mill is unique as a reminder of the early economy of the area. White's Mill is one of the last remaining gristmills in the region that is still open to the public. A nonprofit group is working to obtain grants to restore the mill and develop it into a historic and cultural center. (Courtesy Donna Akers Warmuth.)

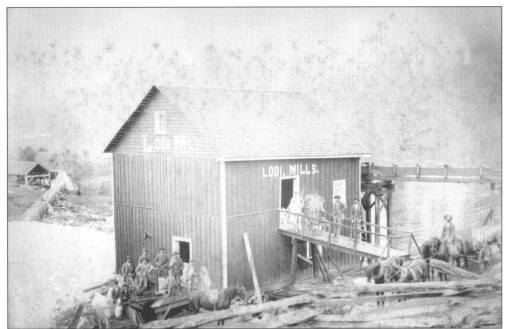

LODI MILL. George Graham owned and operated the Lodi Mill or Mock's Mill for many years. The earliest section of the mill was a log structure built by James and Robert Rhea and dates to *c.* 1829. The mill was built on Cedar Creek at the junction of today's Rivermont Drive and S.R. 803, but only a section of the foundation remains. (Courtesy Marilou Hall Preston.)

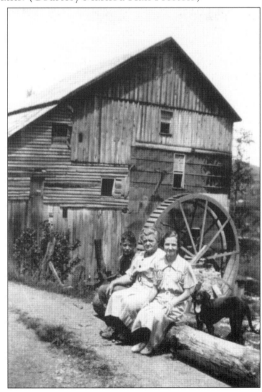

LOAFING AT LODI MILL, C. 1936. Pictured from left to right are James D. Mock (1923–1944), Margaret Alma Clark (1886–1961), and Margaret Juanita Mock Neese (born 1921). The Old Lodi Mill was also known as Mock's Mill. It was located on Cedar Creek near the junction with the Middle Fork of the Holston River. This mill was one of the few mills of log construction and stood for many years. (Courtesy Juanita Mock Neese.)

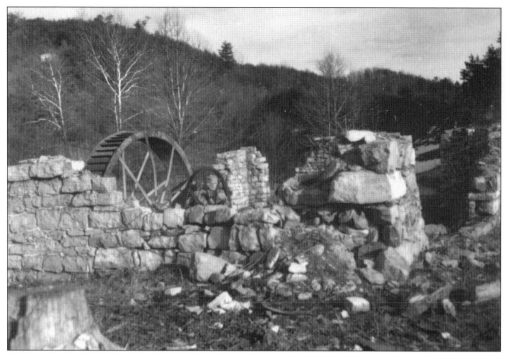

VANCE'S MILL. Vance's Mill was located on Spring Creek on the old Jonesboro Road and was likely built in the early 19th century. Only the stone foundation remains in the photograph taken by Douglas Patterson, a well-known local photographer. (Courtesy Douglas A. Patterson.)

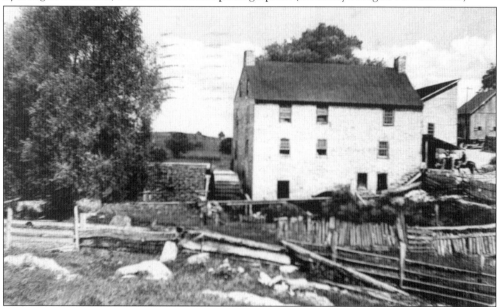

CLAPP'S FACTORY. This mill was also known as the Old Stone Mill and stood at the southern limits of Abingdon. Built before 1815, the mill was a fulling mill and later became a grist and flour mill. It was originally built to process woolen textiles. The two-story limestone building was destroyed by fire in 1964. Clapp's Factory is significant as one of Washington County's earliest commercial ventures. (Courtesy Lowry Bowman.)

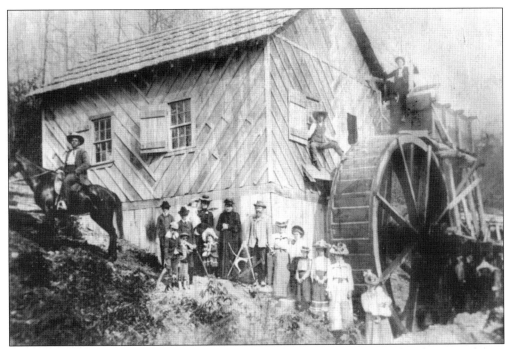

MILTON FLEENOR MILL. The Milton Fleenor Mill was located above Slaughter Road near Campground Road near Benhams. Dr. Joe Fleenor is the man astride the horse. The gentleman in the center of the photograph may be holding a Masonic symbol. (Courtesy Joe Smith.)

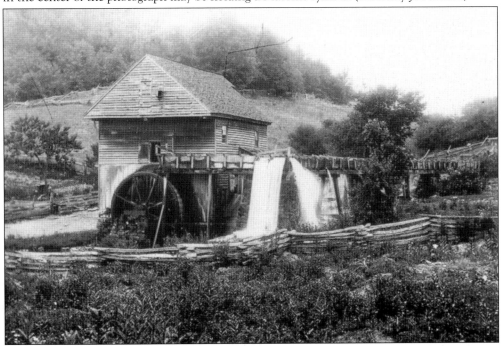

GEISLER'S MILL. The roof overhang of this mill is unusual to mill designs of the area. Geisler's Mill, originally known as Morell's Mill, was located at S.R. 80 and Logan Creek. The wooden flume is visible in this photograph. The mill burned in about 1936. (Courtesy MOMA.)

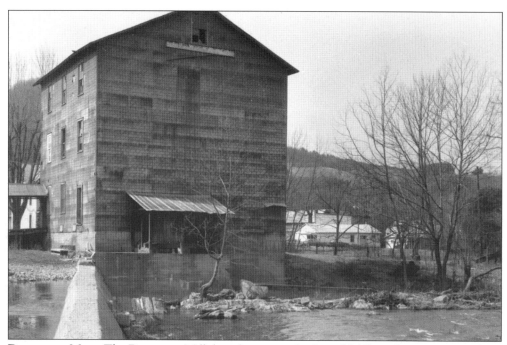

DAMASCUS MILL. The Damascus Mill, later known as the Laurel Milling Company, was a busy mill of the area. It was built on Beaver Creek. The original structure was incorporated into the existing Damascus Mill Restaurant. (Courtesy Lowry Bowman.)

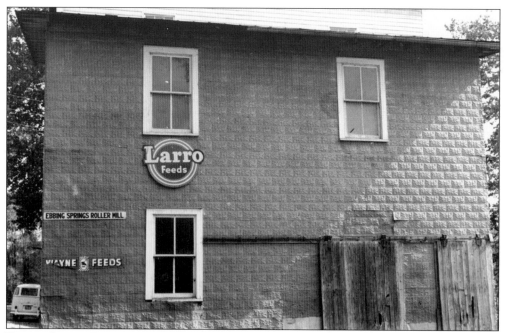

EBBING SPRING ROLLER MILL. The three-story DeBusk or Ebbing Spring Roller Mill was built after the 1870s on the Middle Fork of the Holston River. The building contained rollers, bolters, and sifting machinery. It is one of the few mills known to have been built only for roller operation. (Courtesy Lowry Bowman.)

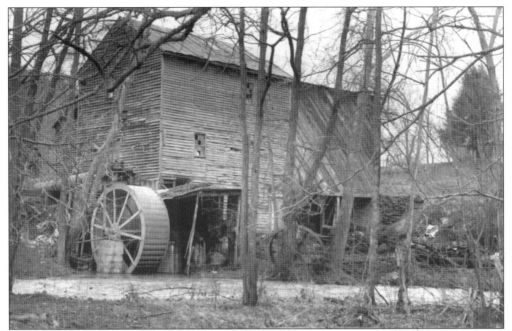

PARK'S MILL. For many years, Park's Mill produced a variety of custom-ground livestock feeds. The mill ran three runs of millstones and roller mills in its heyday. The mill is still standing on S.R. 672 or Park's Mill Road and is open for visitors. (Courtesy Lowry Bowman.)

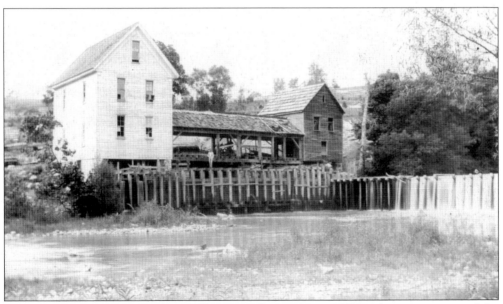

LOVES MILL. Now known as J. T. Wilkinson and Sons, Loves Mill has been a mainstay of the community. Built c. 1837, it once housed a post office. Additions have been built over the years. The wooden dam can be seen along the creek. Today the Wilkinson Mill is one of the last remaining mills to sell livestock feeds. (Courtesy Debbie Wilkinson Tuell.)

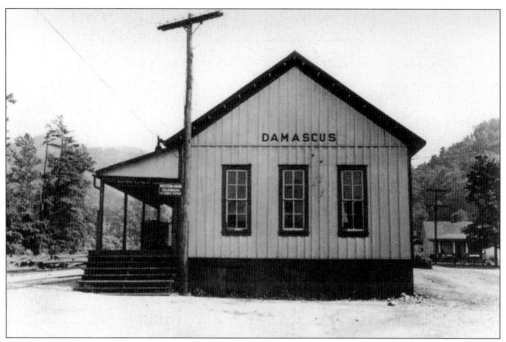

DAMASCUS TRAIN DEPOT. This train depot was located on the Virginia-Carolina and later the Norfolk and Western Railway near today's downtown Damascus. Today the old railbed has become the Virginia Creeper Trail, a pedestrian and bike trail that runs between Whitetop Mountain and Abingdon. (Courtesy Jeffrey Weaver.)

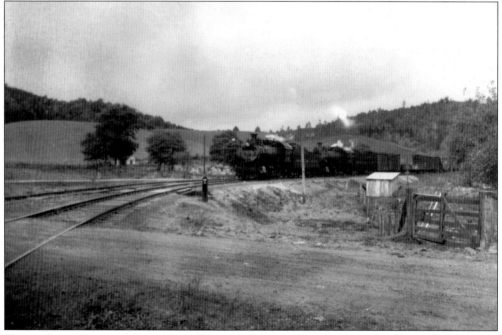

GREEN COVE STATION. Green Cove Depot was built in 1914 for the railroad line. It also served as a post office. Today the building has been donated by William Buchanan's family as a visitor center for the Virginia Creeper Trail. (Courtesy Douglas A. Patterson.)

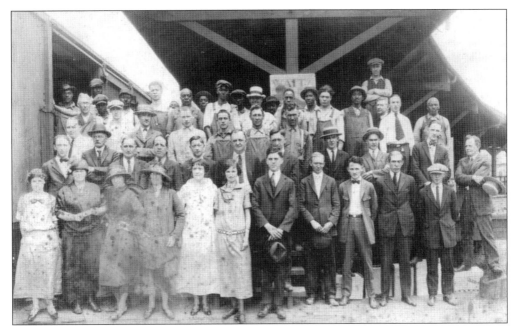

ABINGDON DEPOT. This group of individuals is posed at the Abingdon depot station. Some of them may be railroad employees, while others in suits appear to be businessmen. The few ladies in front are dressed in the styles of the 1920s. Several African Americans are present in the group. (Courtesy James Miller.)

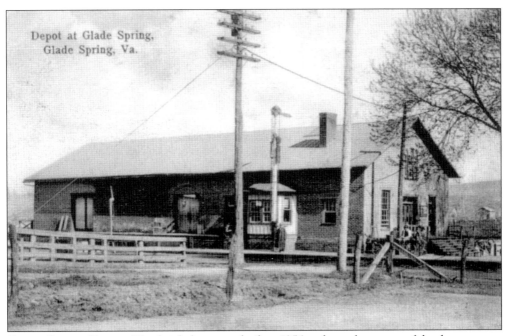

GLADE SPRING DEPOT. This brick depot was built *c.* 1856 and was the center of the depot square area in Glade Spring. Much of the town's growth was due to its location as a railroad depot. (Courtesy Ida Mae McVey.)

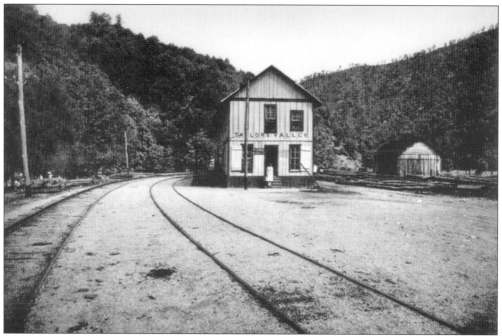

TAYLOR'S VALLEY DEPOT. The two-story depot building in Taylor's Valley stood by the railroad tracks. The remote community had a post office after 1906. Taylor's Valley is located off Tennessee Highway 91 outside Damascus. (Courtesy Jeffrey Weaver.)

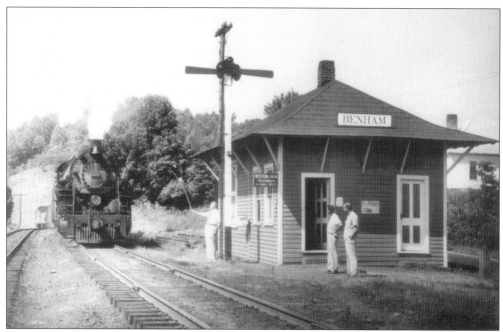

BENHAMS DEPOT. A train is steaming into the Benhams depot station. A Western Union Telegraph office was also in the building. A post office was located here from 1880 until 1959. Benhams flourished as a railroad stop after the Civil War, but the last passenger trains ended in 1947. Today it's a peaceful residential community. (Courtesy Joe Smith.)

Five

AGRICULTURE AND LANDSCAPES

Long the lifeblood of this region, agriculture has decreased in its importance to the economy. Many families still try to hold onto the family farms, but sadly farming is more of a hobby than a livelihood. To make a living, the settlers cleared the land and planted crops and raised livestock. Extra produce such as chicken, eggs, or vegetables were bartered or sold in order to buy coffee, sugar, or clothing. Cultivation methods have changed from handheld tools such as a scythe, then to horse and ox-drawn plows, and finally to mechanized tractors. Major agricultural exports of the area in the past included corn, wheat, tobacco, hay, cattle, and sheep. The county was a leading state producer of many of these items.

Burley tobacco became the farmer's "meat and potatoes" after the 1930s and helped to pay land taxes, send children to college, and purchase new farm machinery. This area was a major producer of burley tobacco within Virginia. The continued importance of the Tobacco Festival and Washington County Fair is a testament to the significant role that agriculture has played.

The landscape here is within the valley and ridge area of the valley of Virginia. Water resources such as man-made lakes, like the South Holston Dam and Hidden Valley, provide recreational opportunities. Rivers are excellent for fishing, and hunting is still a hobby of many residents. Whitetop Mountain, part of the Mount Rogers National Recreation Area, towers over the land at 3,576 feet. Much of the county is still rural in nature, although development pressure along the Interstate-81 corridor is increasing.

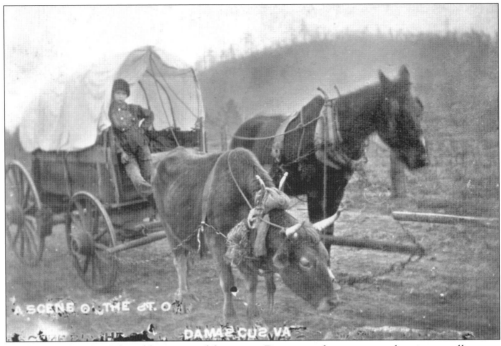

BY HORSE AND OX. This older postcard from near Damascus shows a young boy in a small wagon drawn by an unlikely combination of horse and ox. With these beasts of uneven gaits, the ride couldn't have been very smooth. (Courtesy Louise Fortune Hall.)

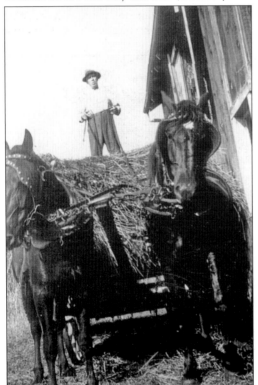

L. R. JOHNSON. In this early photograph, L. R. Johnson is pictured standing atop a hay wagon on his farm in Abingdon. Cutting and putting up the hay was an important chore in order to feed the livestock through the winter. (Courtesy Irene Johnson Meade.)

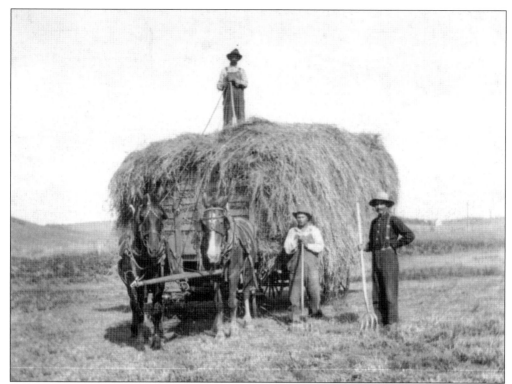

MAKING HAY. Hay has been loaded on the wagon by pitchfork, and the team stands ready to haul it to the barn in this early photograph from the Friendship community. The man standing on top of the loose hay on the wagon and driving the horses had the most risky job. (Courtesy Ida Mae McVey.)

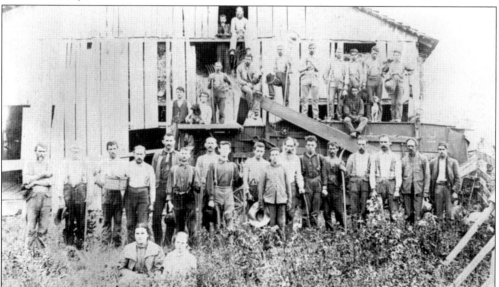

PUTTING UP HAY. This group of Washington County friends and family members are taking a break from their hard work of putting up hay in the barn. Growing hay, cutting it, and baling it still takes up much of the time of the area's farmers. (Courtesy Lowry Bowman.)

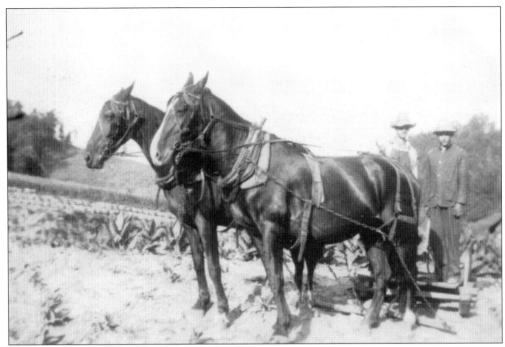

PLOWING RICH VALLEY. These mules are hooked up to a plow steered by two farmers in what appears to be a tobacco field or cabbage patch in Rich Valley. (Courtesy Joe Smith.)

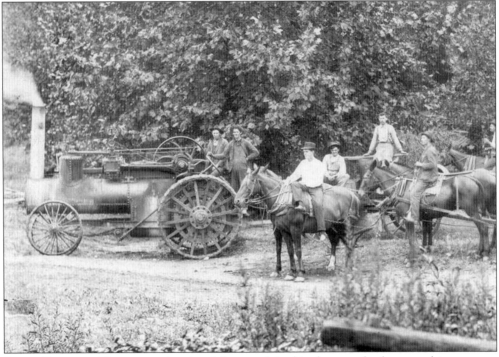

STEAM TRACTOR. These men take a break from work in this photograph of a steam-driven tractor in the early 1900s. Agricultural advances helped make farming more efficient as time passed by. Today tractors such as this are collectibles and appear in tractor shows. (Courtesy Joe Smith.)

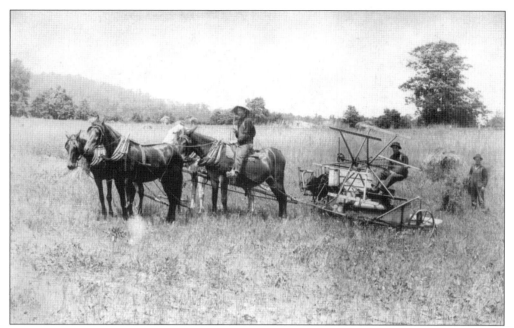

BINDING WHEAT. Four mules or horses are harnessed to draw this machine that binds wheat. Wheat is no longer grown in the region today. (Courtesy Joe Smith.)

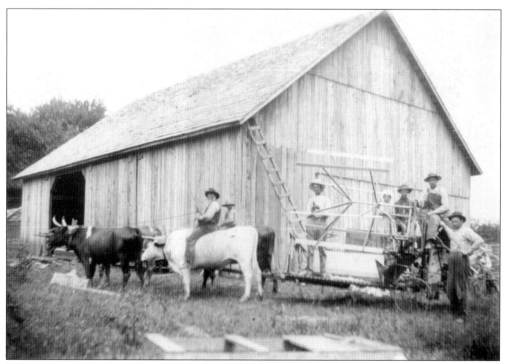

WHEAT BINDER. Shown is a wheat binder in a field in the Friendship area. Four oxen are hooked to the machine, indicating the size of the equipment. The ladder against the barn would have been used to access the loft from the exterior. (Courtesy Dorothy Ray.)

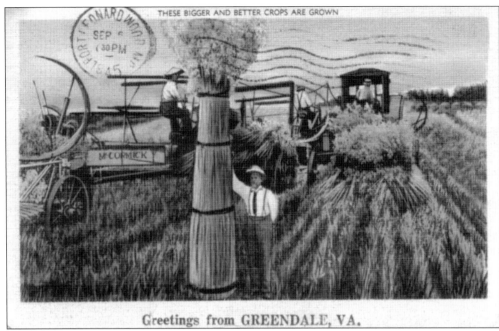

GREENDALE GREETINGS. Postmarked in 1945, this appears to be a standard stock postcard that the company would imprint with a locality's name. Bragging about the size of one's crops is still a popular tradition. (Courtesy Jack Taylor.)

SHALLOWFORD. This postcard, dated November 3, 1910, was sent to Sadie Brown in Alvarado. It shows the bridge at Shallowford, which crossed the Middle Fork of the Holston River. This area was a less-deep section of the river that could be crossed more easily. (Courtesy Harry Minnick.)

DELMAR GREETINGS. Stock postcards were produced by companies and imprinted with local community names. Delmar was a whistle-stop on the Virginia Creeper Railroad between Alvarado and Drowning Ford. (Courtesy Jack Taylor.)

TOBACCO JUDGING. This scene was taken at the annual Washington County Tobacco Festival. The cultivation of burley tobacco began in the region in the 1930s, and it quickly became a mainstay of farming families. (Courtesy Lowry Bowman.)

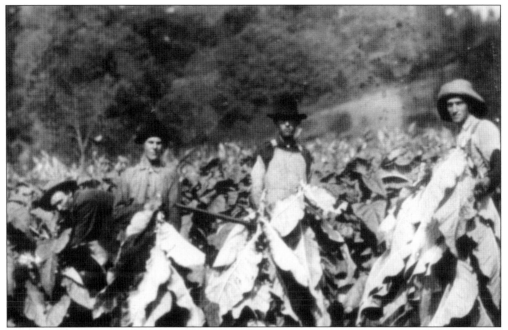

CUTTING TOBACCO. Burley tobacco leaves have been cut and are being strung on a pole to be hung up in the barn to dry. Tobacco brought in extra cash, and although it was labor intensive, the federal allotment system enabled families to keep their small family farms. Now that the allotment system has ended, the cultivation of tobacco has decreased. (Courtesy Colleen Davenport Taylor.)

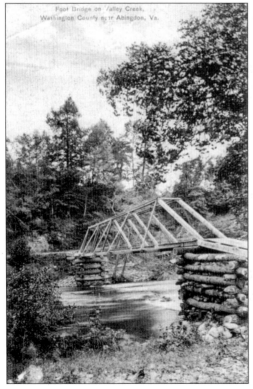

GLENFORD. Postmarked September 9, 1909, this postcard pictures Glenford. This long-forgotten community was located near S.R. 693 or Litchfield Road and S.R. 700 or Rich Valley Road. Note the log foundation for the metal bridge. The card was written from Mary E. Scott to E. L. Minnick. (Courtesy Harry Minnick.)

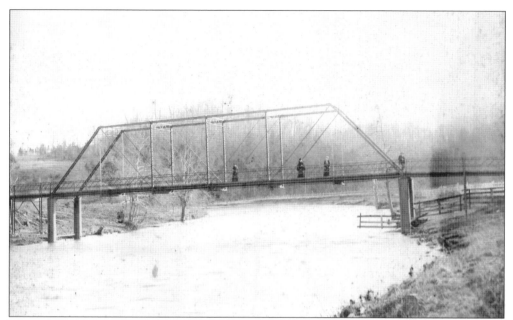

MIDDLE FORK OF THE HOLSTON BRIDGE. Taken in the early 20th century, this photograph shows the Middle Fork Bridge. It was replaced about 1970 by the modern bridge in place today. (Courtesy Marilou Hall Preston.)

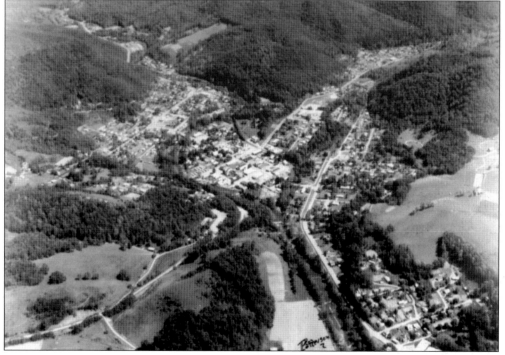

AERIAL VIEW OF DAMASCUS. This photograph, taken by local photographer Doug Patterson, provides a view of the entire town and the roads leading in and out of Damascus. Most of the later growth occurred here because of the timber and the railroad. The forested lands in the background are part of the Mount Rogers recreation area. (Courtesy Louise Fortune Hall.)

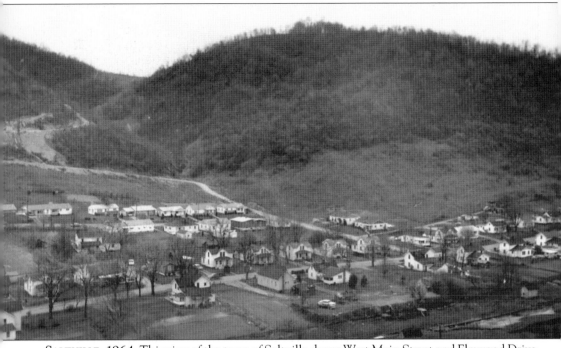

SALTVILLE, 1964. This view of the town of Saltville shows West Main Street and Elmwood Drive. This area was called Smokey Row because of the smoke produced from rows of salt furnaces. This small community has historically been a key location because of its mineral resources. From Native Americans to a probable Spanish expedition here, the town has been an attraction because of its natural resources. Paleontologists have discovered remains of prehistoric animals, such as mastodons and mammoths, in the mud around the lake. As the western frontier opened, several families settled in the Saltville area by the 1790s. Early industrialization of the area occurred with the Preston and King families' salt mines in the early 1800s. Gypsum deposits in nearby Plasterco were also a natural resource that was exploited by early industrialists. During the Civil War, Saltville was the main source of salt for the Confederate armies. Union troops attempted several times to capture the wells and finally did succeed in destroying the salt works. Today little industry remains in the town, and the economy is struggling. However, the Museum of Middle Appalachians located in downtown Saltville has preserved the unique history of the area and attracts visitors from near and far. (Courtesy MOMA.)

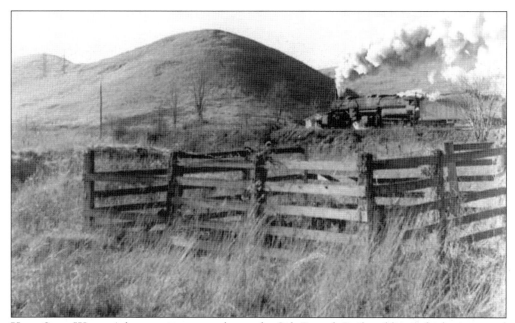

KING SALT WELL. A locomotive steams by on the Salt Branch Railroad line, which connected at Glade Spring with the Norfolk and Western Railroad. The fence surrounds the original William King salt well, which dates to the late 1700s. By 1792, King had settled in Saltville and was manufacturing salt. King became a major landowner in Saltville and Abingdon because of a fortune accumulated from mining salt. (Courtesy MOMA.)

EARLIEST COUNTY TOMBSTONE. This tombstone for Mary Boyd is reputed to be the earliest identified grave in Washington County. It is located in the Poston Cemetery above the falls of the North Fork of the Holston River. The inscription reads, "Mary Boyd died Febr. 17, 1773, aged 3 years, Alexr and Elizb Boyd." According to legend, she drowned when the family's boat capsized while crossing the river falls. (Courtesy MOMA.)

HOLSTON RIVER RAPIDS. This scenic view of the North Fork of the Holston River shows the natural beauty of the river. First a source of water and transportation, the rivers now offer recreational opportunities. (Courtesy Douglas A. Patterson.)

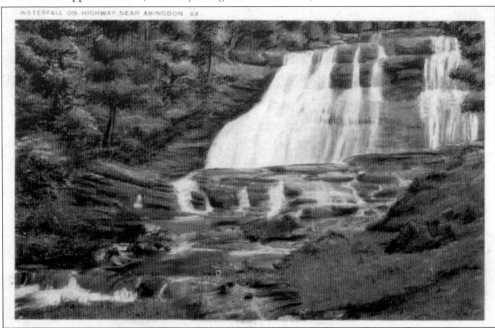

WATERFALL NEAR ABINGDON. One of the many scenic waterfalls in the area is pictured in this older postcard produced by the Knoxville Engraving Company. With the abundant water resources, waterfalls such as this are common in the area. (Courtesy Donna Akers Warmuth.)

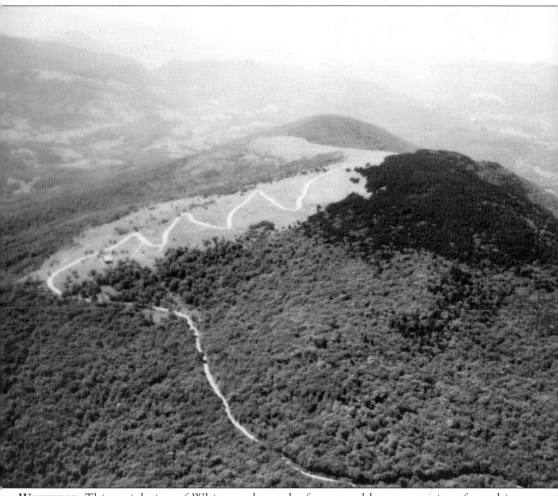

WHITETOP. This aerial view of Whitetop shows the forests and long-range views from this mountain. The rugged mountain was timbered in the early 1900s and had a train station. The curving road ascending the top is a challenge, but the view from the top is incredible. The county lines of Washington, Grayson, and Smyth Counties meet at the summit. The mountain is part of the Mount Rogers National Recreation Area and is crossed by the Appalachian Trail. The mountain is a major feature of the wealth of recreational opportunities in this area. (Courtesy Douglas A. Patterson.)

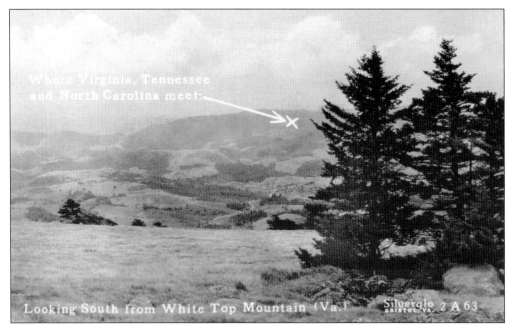

Looking South from White Top Mountain (Va.) Silverglo 2 A 63

VIEW SOUTH FROM WHITETOP MOUNTAIN. This postcard shows the incredible view from Whitetop Mountain at an elevation of 5,520 feet. The name is derived from a large, cleared area or bald that appears white from a distance. The location where the states of Virginia, Tennessee, and North Carolina meet is marked with an X. (Courtesy MOMA.)

HIDDEN VALLEY LAKE. Brumley Mountain and Hidden Valley Lake are shown in this aerial photograph by Doug Patterson. Developed in 1964, the 61-acre lake is a recreational amenity in the area. The surrounding 6,400-acre Hidden Valley Wildlife Management includes camping and picnic areas. (Courtesy Douglas A. Patterson.)

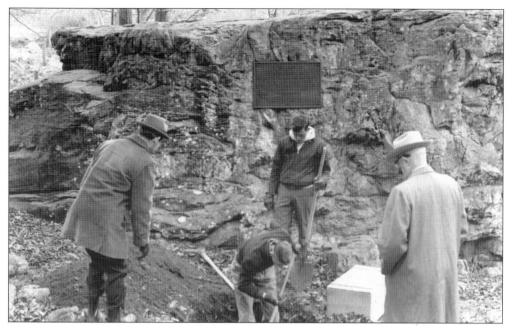

DOUGLAS WAYSIDE. This seems to be the reburial of the remains of John Douglas at the recreational area along U.S. 58/19. In 1790, two young men left Abingdon to warn other settlements about a Native American attack, and John Douglas was killed by Native Americans at this location. His remains were buried near a large rock and later moved for highway construction in the 1960s, likely shown here. (Courtesy Lowry Bowman.)

SEVEN SPRINGS. The Seven Springs resort was located outside Glade Spring near the Litz community. Each spring had a decorative stone cathedral built by L. Curtiss Vinson. The springs included sulphur, iron, chalybeate, alum, limestone, and freestone. (Courtesy Lowry Bowman.)

CLINCH MOUNTAIN FIRETOWER. The location of this firetower and house became locally famous in well-known local journalist Jack Kestner's book *Firetower*. Kestner was a former tower operator there. (Courtesy Jack Kestner family and Hayter's Gap branch of the Washington County Public Library.)

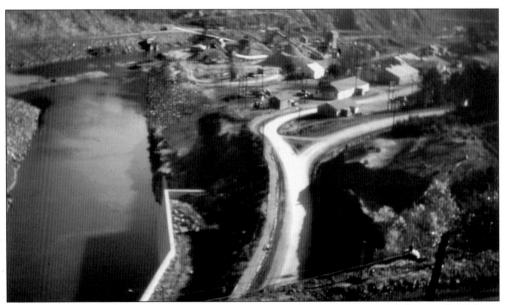

SOUTH HOLSTON LAKE AND DAM CONSTRUCTION. The construction of the South Holston Dam took place from 1942 until 1950. The 7,580-acre lake is managed by the Tennessee Valley Authority. Boating and fishing are favorite activities, and picnic areas have been developed along the shore. (Courtesy Douglas A. Patterson.)

Six

RECREATION
AND SOCIALIZING

In the earliest days, social life was centered mainly around family and church. Revivals, singings, and dinner on the grounds were major social events. Past recreational activities were usually combined with farm work, and groups enjoyed making apple butter, raising barns, shucking corn, and making quilts together. Market days in the small communities were also times to meet and greet neighbors.

Civic and community clubs later evolved, beginning with the Masons, the Odd Fellows, and various trade groups. Community fairs were held in Greendale and other smaller residential areas. These fairs evolved into the Burley Tobacco Festival and Washington County Fair, held since 1950 and still going strong today.

Today the area's natural resources are not only to be admired, but also provide many outdoor activities, including biking, hiking, fishing, and outdoor sports. The South Holston Lake and Hidden Valley Lake are man-made bodies of water, which add to outdoor opportunities. The Virginia Creeper Trail, nationally rated as one of the best biking trails, runs from Abingdon to Damascus and the top of Whitetop Mountain. Festivals such as the Whitetop Maple Festival, the Virginia Highlands Festival, Plumb Alley Day, and Appalachian Trail Days in Damascus are annual events that draw residents and visitors alike. Numerous civic groups and churches, as well as country clubs and golf clubs, provide ample avenues for folks to enjoy an active social life.

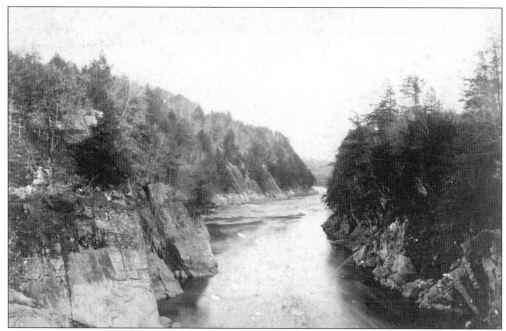

SOUTH FORK OF HOLSTON. This is a photograph of the South Fork of the Holston River prior to the Tennessee Valley Authority's construction of a dam to form South Holston Lake. Begun in 1942, the project was completed in 1950 to provide flood control, power production, and aquatic resources. The 7,500-acre lake stretches from outside Abingdon into northeast Tennessee and remains a major recreational resource for the region. (Courtesy Tom McConnell.)

RAILROAD BICYCLES. These two unidentified men were riding bicycles designed to ride on a railroad in the Mendota area. The gentlemen do seem dressed up for mere exercise, so perhaps they were taking a shortcut by railway to a social occasion. (Courtesy Joe Smith.)

WASHINGTON CHAPEL PICNIC. Washington Chapel was organized in 1887, and the Washington Chapel school once stood near the site. Pictured at this picnic on the church grounds are the following individuals: ? Hagy, Anamalia Hawthorn, Stella Ryne, Bill Colley, Margaret Raines, Arlean Raines, Barbara Colley, Henneta Hagy, Albert Raines, Arthur Hawthorn, Ben Sawyers, Mack Lester, and Ewell Minnick. (Courtesy Harry Minnick.)

KELLY'S CHAPEL. A fine summer day provided the backdrop for this church dinner at Kelly's Chapel, located in the Friendship community. Kelly's Chapel was built in 1857 on land deeded for the church by Andrew and Mary Jane McKee. (Courtesy Dorothy Ray.)

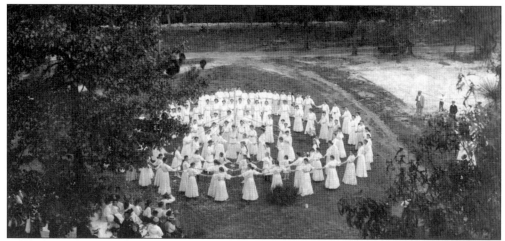

MAY DAY. A group of young girls clad in long, white dresses appear to be dancing and crowning a May Queen in this celebration. This event may have happened at Stonewall Jackson Institute, a girls' school in Abingdon, which operated from 1869 until 1930. The history of May Day goes far back to the spring fertility rites of Rome. (Courtesy Tom McConnell.)

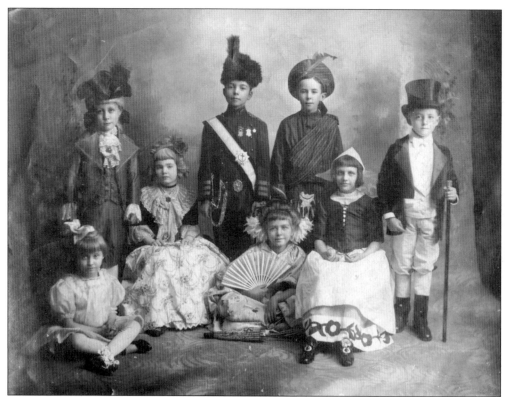

COSTUMED CHILDREN. This unidentified group of children strike a serious pose in costumes from countries around the world. Plays such as these would have included children from more well-to-do households of the area. (Courtesy Tom McConnell.)

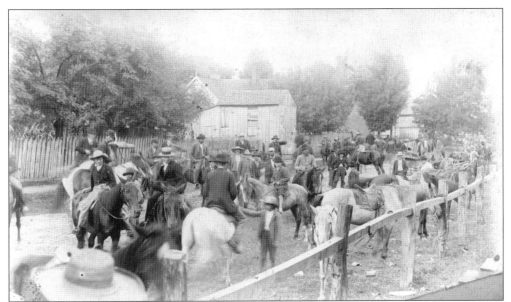

HORSE TRADING. This *c.* 1900 photograph shows men trading horses on market day. This photograph may have been taken behind the Washington County Courthouse in Abingdon, in an area known as Jockey Lot. Men would gather, gossip, trade horses and dogs, and visit. (Courtesy Kitty McConnell Henninger.)

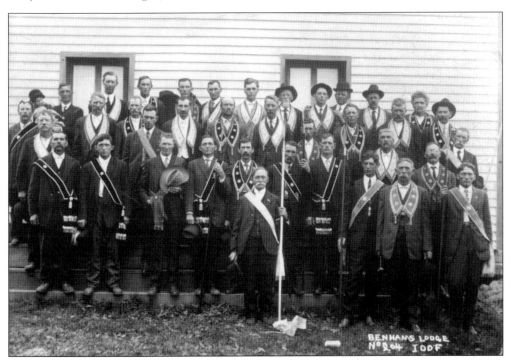

BENHAMS ODD FELLOWS LODGE. Male clubs, such as this one in Benhams, were common in the early 1900s and served to unite the community. Note that most of the men are holding their hats, as it was customary to remove them for photographs. The sashes and collars are special symbols of the Odd Fellows. (Courtesy Joe Smith.)

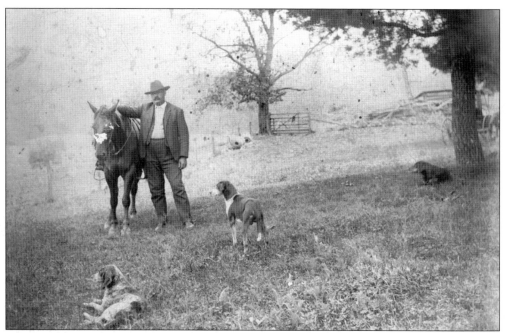

Will Clark. "Big Will" Clark stands with several hound dogs at his farm near Deadmore Street and the old fairgrounds outside Abingdon. Dogs such as these were used for hunting and are still favorite pets today. (Courtesy Gerald C. Henninger.)

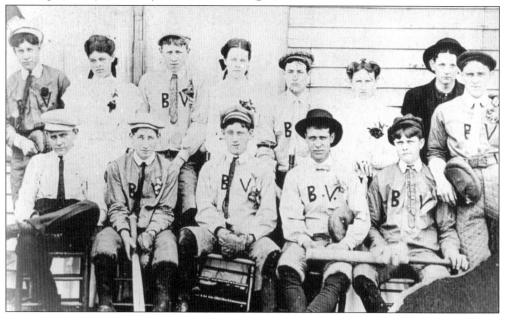

Buena Vista Baseball. This 1908 photograph shows the popular Buena Vista baseball team from Plasterco. Note the leggings, quilted uniforms, and ties. Pictured from left to right are (first row) Sanders Farris, Ben Riggins Farris, Tom Campbell, George Hodgson, and David Hicks; (second row) Wyndham David "Chaney" Farris, Cora Sanders Farris, Joe Campbell, Rachael Grady Campbell, Harry Akern, Stella Campbell Hicks, Will Farris, and Will "Quedot" Farris. (Courtesy MOMA.)

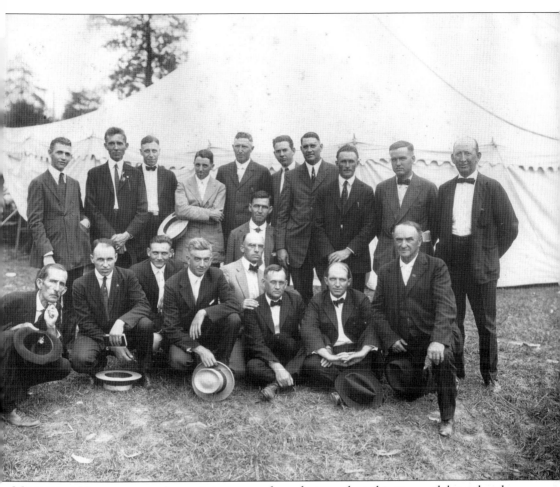

MINISTERS' HOMECOMING. Area ministers pose for a photograph at this two-week-long church homecoming held in the summer of 1921 in front of George Thomas's house. The site of this event is now under the South Holston Lake. Pictured from left to right are (first row) Rev. Allen Jones; Rev. Fleenor Comerford; Rev. B. L. Bowman, D.D.; Rev. Frank E. Clark, D.D.; Rev. Tom Wix; Rev. J. M. McChesney, D.D.; Rev. R. Dabney Carson, D.D.; and Rev. Johnny Naff (Methodist); (second row) Rev. Dan H. Graham; (third row) Willie Whitlock; Rev. Tilden Scherer, D.D.; Rev. Walter Harrop, D.D.; Rev. Earl Guthrie; Rev. John Offield; Thomas Jones; Rev. David Franklin Bruce McConnell, D.D.; Rev. Robert Berry; Rev. Walter K. Keys; and Rev. Thomas Jasper McConnell, D.D. Homecomings continue to be a popular tradition for area churches. (Courtesy Tom McConnell.)

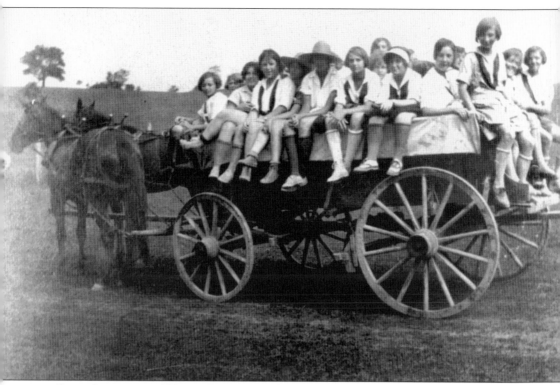

CAMP GLENROCHIE WAGON RIDE C. 1920. This summer camp for girls was held on a 16-acre tract and included a kitchen, stables, screened dining porch, and cabins for camp directors. Begun by Mamie and Willoughby Reade, the camp operated during summers from 1901 until the early 1950s. The camp was well known through the Southeast and attracted many girls to the mountains. It was advertised as "Summer School in Virginia Mountains, Camping a Feature." The camping and outdoor activities soon became more popular than the educational classes. In 1957, the Glenrochie Country Club purchased the campground and adjoining land to establish a golf course. (Courtesy Lowry Bowman.)

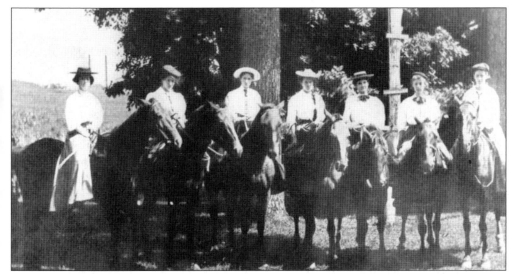

GLENROCHIE RIDERS, C. 1910. These young ladies are enjoying riding at Camp Glenrochie, which not only offered classes in literature, history, and art, but also activities such as camping, lawn tennis, canoeing, and horseback riding. The outdoor activities proved more popular than the culture classes. (Courtesy Lowry Bowman.)

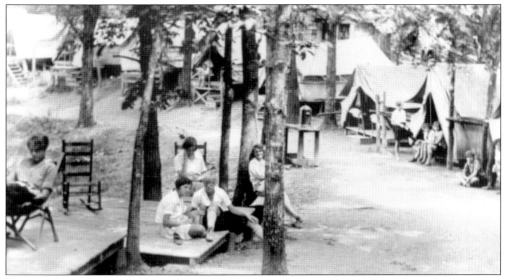

CAMP GLENROCHIE. Tents are up, and girls lounge at this camp that operated at the current location of the Glenrochie Country Club for about 50 years. Mamie and Willoughby Reade operated the camp during the summers. Campers slept in tents on wooden platforms. (Courtesy Lowry Bowman.)

GLENROCHIE COUNTRY CLUB TOURNAMENT DIRECTORS. In this 1960s photograph, the directors of the club tournament are pictured. From left to right are Jack Bundy, John Dellis, John Bralley, Walter Speer, unidentified, Bill Webster, and Harry Coomes. Bill Webster was the club pro and grounds superintendent at the club for 32 years. (Courtesy William and Betty Webster.)

GLENROCHIE LADIES GOLF TOURNAMENT. This 1960s photograph shows the winners of a ladies' golf tournament at Glenrochie. Pictured from left to right are Fern Bondurant, Betty Webster (wife of Bill Webster, the club pro), Marylyn Yeager, Becky Bondurant, unidentified, Hilda Smeltzer, Kathleen Kelly, Gladys Snead, and Rose Dunn. (Courtesy William and Betty Webster.)

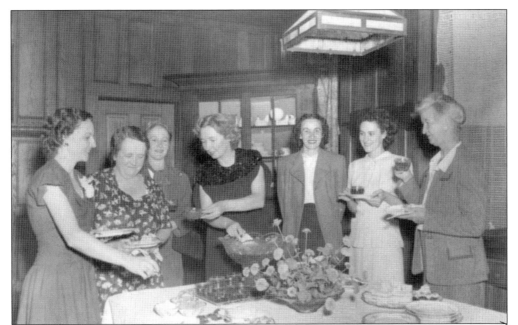

Au Currant Bookclub Officers, 1947. The Au Currant Bookclub was begun in 1930 in Damascus by Mildred Wright Dungan and over the years sponsored a school library, Girl Scouts, various town projects, and a scholarship. This September 25, 1947, photograph shows their officers: from left to right are Louise Hall, Ella Burrow, Frances Wingfield, Mildred Dungan, Kathleen Mast, Ella Scott Wright, and Nannie Hyde. (Courtesy Louise Fortune Hall.)

Tobacco Float. This tongue-in-cheek slogan was posted on a float in the Burley Tobacco Festival parade held in downtown Abingdon since 1950. The Tobacco Festival, now called the Washington County Fair, was begun in order to celebrate the end of harvest season and the importance of agriculture as a way of life. (Courtesy Lowry Bowman.)

TOBACCO FESTIVAL PARADE. Everyone looked for the "twirlettes" twirling their batons in this Abingdon parade. The parades included floats from civic groups, politicians, schools, and clubs, as well as marching bands, cloggers, and majorette groups. The parade and Washington County Fair still are popular events today. (Courtesy Lowry Bowman.)

MONGLE SPRINGS CABIN. Mongle Spring was known for its springwater and was a popular location for vacation cabins. Many of these cabins are still there today. This area is located on the North Fork River Road east of U.S. 19/58. The area was named for Jacob Mongle, who owned some of the first lands surveyed on the Holston River. (Courtesy Lowry Bowman.)

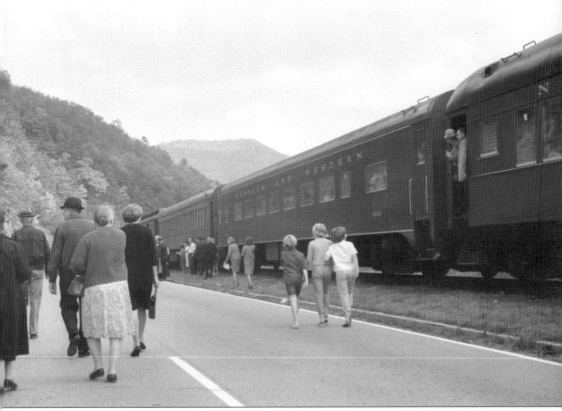

DAMASCUS EXCURSION TRAIN. This 1967 photograph shows an excursion train trip on the Norfolk and Western train, along with a parade through Damascus. These trips were often planned during the fall leaf season and were very popular. The excursions were a reminder of the past dominance of the railroad in this small town. Today the railroad route is the Virginia Creeper Trail, one of the first rails to trails conversions in the state. Folks are walking along the Norfolk and Western passenger cars on this excursion trip from Damascus. (Courtesy Lowry Bowman.)

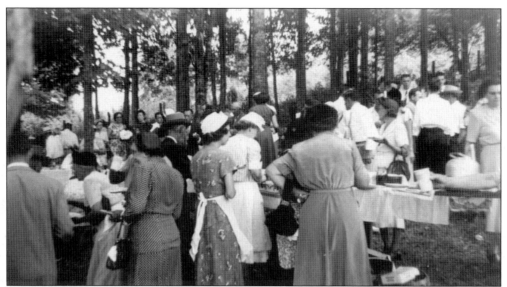

CAMPGROUND CHURCH DINNER. Dinner on the grounds at local churches, such as this one shown at Campground Church in the Benhams area, were very popular until the mid-1900s. Church was the main social gathering place, and everyone in the community attended to praise God and visit with friends. Deviled eggs, fried chicken, country ham, and corn bread would have been among the Southern dishes served. (Courtesy Joe Smith.)

SOUTHWEST VIRGINIA 4-H CENTER. This older postcard shows several of the buildings that comprise the complex for the Southwest Virginia 4-H Center. Local members of 4-H still attend camps and special events here, and it also provides meeting facilities. (Courtesy Donna Akers Warmuth.)

Southwest Virginia
4-H Center

THE 4-H CENTER. The Southwest Virginia 4-H Center was built in 1959 and serves 13 counties in the region. Many special events have been held there, including 4-H camps, horse shows, balloon rallies, reunions, and fund-raisers. A fund-raising effort is underway to upgrade and keep the center as a vital part of the community. Few folks remember that the small cottages in the photograph were originally housing for a poor farm, which operated at the site from the mid-1800s until the 1930s. The residents raised crops in the fields to provide their board. The cemetery where the residents were buried in unmarked graves lies under a pasture on an adjacent farm. Before the welfare system, poor farms were common in every community to take care of those folks who didn't have family to help them. (Courtesy Southwest Virginia 4-H Center.)

Across America, People are Discovering Something Wonderful. Their Heritage.

Arcadia Publishing is the leading local history publisher in the United States. With more than 3,000 titles in print and hundreds of new titles released every year, Arcadia has extensive specialized experience chronicling the history of communities and celebrating America's hidden stories, bringing to life the people, places, and events from the past. To discover the history of other communities across the nation, please visit:

www.arcadiapublishing.com

Customized search tools allow you to find regional history books about the town where you grew up, the cities where your friends and family live, the town where your parents met, or even that retirement spot you've been dreaming about.